and damask the same And further that every such offender or offenders shall forfeit five shillings for every print which shall be found in his her or their custody either printed or published and exposed to sale or otherwise disposed of contrary to the true intent and meaning of this Act the one moiety thereof to the Kings most Excellent Majesty his heirs and successors and the other moiety thereof to any person or persons that shall sue for the same to be recovered in any of his Majestys Courts of Record at Westminster by Action of Debt Bill Plaint or Information in which no Wager of Law Essoign Privilege or Protection or more than one Imparlance shall be allowed PROVIDED nevertheless that it shall and may be lawful for any person or persons who shall hereafter purchase any Plate or Plates for printing from the original Proprietors thereof to print and reprint from the said plates without incurring any of the penalties in this Act mentioned AND Be it further Enacted by the authority aforesaid that if any action or suit shall be commenced or brought against any person or persons whatsoever for doing or causing to be done any thing in pursuance of this Act the same shall be brought within the space of three months after so doing and the defendant and defendants in such action or suit shall or may plead the General Issue and give the special matter in evidence and if upon such action or suit a verdict shall be given for the defendant or defendants or if the plaintiff or plaintiffs become nonsuited or discontinue his her or their action or actions then the defendant or defendants shall have and recover full costs for the recovery whereof he shall have the same remedy as any other defendant or defendants in any other case hath or have by law PROVIDED always AND Be it further Enacted by the Authority aforesaid that if any action or suit shall be commenced or brought against any person or persons for any offence committed against this Act the same shall be brought within the space of three months after the discovery of every such offence and not afterwards any thing in this Act contained to the contrary notwithstanding AND Be it further Enacted by the authority aforesaid that this Act shall be deemed adjudged and taken to be a publick Act and be judicially taken notice of as such by all Judges Justices and other persons whatsoever without specially pleading the same./

Press 3. line 30. After (notwithstanding) Insert

And Whereas John Pine of London Engraver doth propose to engrave and publish a sett of prints copied from several pieces of Tapestry in the House of Lords and his Majestys Wardrobe and other drawings relating to the Spanish Invasion in the Year of our Lord One thousand five hundred and Eighty Eight Be it further Enacted by the Authority aforesaid that the said John Pine shall be intitled to the benefit of this Act to all intents and purposes whatsoever in the same manner as if the said John Pine had been the Inventor and Designer of the said prints.)

Hogarth's Copyright Act of 15 May 1735
Act 8 Geo II capt 13
House of Lords Record Office
Parchment, 6 × 1 feet

William Hogarth

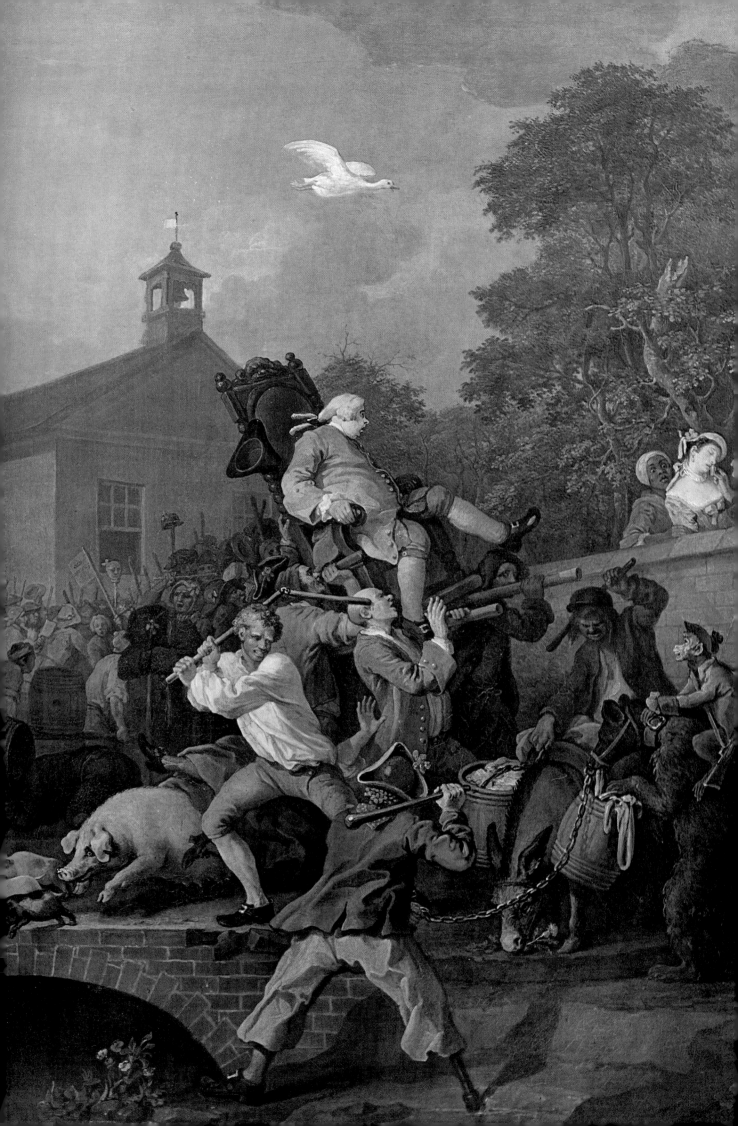

Hogarth

by Lawrence Gowing
with a biographical essay by Ronald Paulson

The Tate Gallery
2 December 1971–6 February 1972

Exclusively distributed in USA and Canada by Boston Book & Art Publisher
655 Boylston Street, Boston, Mass 02116 (SBN 8435-6035-5)

Exclusively distributed in France by Idea Books, 24 rue du 4 Septembre, Paris (2e)

Contents

Cover
Marriage à la Mode II: Shortly after the Marriage
circa 1743 (140)

Frontispiece
An Election: Chairing the Member (*detail*)
circa 1754 (189)

Published by order of the Trustees 1971

Copyright © 1971, The Tate Gallery

Exhibition setting designed by Ralph Holland

Catalogue designed and published by the Tate Gallery
Publications Department, Millbank, London SW1P 4RG
and printed in Great Britain
by Balding & Mansell, London and Wisbech

Foreword

Hogarth, though acknowledged as one of the greatest of English painters, has always been a rather awkward figure to cope with in the context of British art as a whole. In fact for some years now at the Tate Gallery he has been carefully isolated in a room of his own, albeit in his correct historical sequence and usually with every one of his pictures in the collection on view. At the same time his appeal to an audience far wider than the normal art-loving public has perhaps made him slightly suspect to the connoisseur and aesthete. Whatever the cause, large-scale exhibitions of Hogarth's work have been few. The only previous exhibition at the Tate Gallery, an apt celebration of the 1951 Festival of Britain, contained no more than a third of the number of works in the current exhibition. The two-hundredth anniversary of Hogarth's death was celebrated at the British Museum by a splendid display of its own riches but was necessarily confined to prints and drawings. Other exhibitions since the last war have been on an even smaller scale, mainly outside London, and in many cases confined to engravings.

I am therefore particularly glad that we have been able to put on what will probably be the most representative display of Hogarth's work that will ever be possible, given the growing recognition of the disadvantages of sending works of art on loan too frequently. Almost every request we have made for a loan has been granted. The list of distinguished lenders on page 92 speaks for itself, but very special thanks are due to Her Majesty The Queen for lending no fewer than four paintings and sixteen drawings, including the splendid portrait of Garrick and his wife. The Governors of the Thomas Coram Foundation for Children have lent all their works by Hogarth, as have the Trustees of the National Gallery. The Trustees of the British Museum have approved the loan of a magnificent group of drawings, engravings and manuscripts, without which it would have been impossible to represent these aspects of Hogarth's art. A particular debt is owed to the Trustees of Sir John Soane's Museum, whose never-to-be-repeated loan of 'The Rake's Progress' and 'The Election' series, a real case of the exception proving the rule, has supplied the exhibition with the key pictures without which it could not have taken place. Of public galleries outside London the Fitzwilliam Museum has been especially generous, but I would also like to draw special atten-

tion to the generosity of our colleagues in the United States who have in every case been as helpful as the physical condition of their pictures allows. I am even more grateful to those private owners who have to endure blank spaces on their walls so that the public can enjoy their treasures.

The direction of the exhibition has been entrusted to my former colleague Lawrence Gowing, now Professor of Fine Art at the University of Leeds, who is also responsible for the main text and the notes on the individual works. It has been a special pleasure to have him again closely associated with the Tate. The essay on Hogarth's life and character has been contributed by Professor Ronald Paulson of the Johns Hopkins University, Baltimore, and he has provided the information from which the chronology at the end of the catalogue is drawn, but our debt to him extends considerably further. Not only have we been able to rely on his authoritative book on *Hogarth's Graphic Works*, but he has most generously given us access to proofs of his *Hogarth: His Life, Art, and Times* and the vast amount of new information which his researches have brought to light. The designer of the exhibition is Mr Ralph Holland of the Department of Fine Art of the University of Newcastle-upon-Tyne, who has been faced with the usual problem of housing a large number of objects in a rigidly restricted space.

The entry on 'Charity in the Cellar' is based on information kindly supplied by Robert R Wark, and that on 'Archbishop Herring' has been prepared with the assistance of John Ingamells. Further research has been done by Miss Rica Jones at Leeds and two voluntary assistants at the Tate Gallery, Miss Alden Rockwell and Miss Frances Crabtree.

Help in tracing certain paintings has been kindly given by Messrs Thomas Agnew and Sons Ltd, Leggatt Brothers, Sabin Galleries and M Knoedler and Co Ltd. We are also grateful to various owners and institutions that have supplied us with photographs and in particular to Mrs Patricia Barnden of the Paul Mellon Centre. We are much indebted to the Directors and staff of the Victoria and Albert Museum and Leeds City Art Galleries, as well as to Messrs Mallett & Son (Antiques) Ltd who have enriched the exhibition by the loan of very handsome furniture. Finally we must thank the publications department of the National Gallery for lending us a number of colour plates for the catalogue.

Norman Reid
Director

The Life

by Ronald Paulson

William Hogarth was born in the heart of London son of a young schoolteacher from the north o England who came to the city to make his fortune wrote textbooks, found himself correcting for printers and married his landlord's daughter. This was a needy household where Latin and Greek were taught—if not spoken—and words were the centre o consciousness. That it was also a family of Presbyterian roots, but a conforming one, tells something about Hogarth's unquestioning equation through half his career of art and morality; about his concern with reward and punishment, and with young men and women who, not satisfied with a borderline identity try to 'conform' or pass for the next higher rank.

Richard Hogarth taught, wrote, and to make ends meet opened a Latin-speaking coffee house When William was ten the coffee house failed and the family found itself living within the Rules of the Fleet Prison, his father imprisoned for debt and his mother eking out a livelihood selling patent medicines. For five years the Hogarths were imprisoned—the years of William's adolescence that would have seen him either on his way to a university or an apprenticeship When the family emerged, after a special act of Parlia ment to free debtors (another debtor freed was Jonathan Wild), his father was a broken man and William was scarred. He never mentioned this period but he repeatedly introduced prisons, debtors, and jailers, literally and metaphorically, into his paintings

At seventeen, a late age for apprenticing, he went to live with Ellis Gamble, a silver-engraver, to learn his humble craft. He wrote a great deal in later years about this time, emphasising how it kept him from pursuing high art, wasting important years of his life with the copying of 'monsters of Heraldry' Stories survive of his descents into 'low-life' experience and the comic drawings in which he recorded them— activities quite contrary to the rules of apprenticeship Whether due to dissatisfaction or to the death of his father, he did not complete his apprenticeship, but instead set up on his own as an engraver in his mother' house in Long Lane, and issued a shopcard showing the figures of Art and History flanking 'William Hogarth'.

He engraved 'monsters of Heraldry' and small shopcards, but he devoted every spare minute to book illustration, topical prints, and study at the newly founded 'Vanderbank' academy of art. After four years of this further apprenticeship that raised him from silver to copper engraving, he achieved some notice around London with a small satire called *The Taste of the Town*. Thereafter a steady stream of small satiric prints issued from his shop on the latest folly or scandal, culminating in his first major work, a series of twelve large plates based on Samuel Butler's *Hudibras*, treating the story in a mock history-painting idiom that fulfilled the promise of his shopcard.

Vanderbank's art academy had taught him that the highest form of art was history painting. He had served his apprenticeship under the shadow of Sir James Thornhill's allegories at Greenwich and religious histories in the cupola of St Paul's, which showed that an Englishman could succeed at the grand style of painting. And so as he engraved the non-existent (but implied) history paintings that tell the story of *Hudibras*, he was also remedying his deficiency by learning to paint in oils. The first documented painting, with the suitably ambitious title *The Element of Earth* (now lost), was a cartoon made for Joshua Morris' tapestry weavers, which

Morris rejected and paid for only after Hogarth took him to court and produced witnesses including Vanderbank and Thornhill. The earliest surviving paintings that are certainly by Hogarth are *The Beggar's Opera* and *Falstaff examining his Recruits*, sketched directly from the stage. *The Beggar's Opera*, indeed, retains the stage and a visible audience. The play's popularity contributing, this interplay of actors-stage-audience proved popular, and Hogarth made at least five other paintings on the subject, progressing within little more than a year from a clumsy, groping student of oils to a polished painter whose natural expression is through paint.

As he was painting this theme and variations, the House of Commons undertook an investigation of the evils of the Fleet Prison, which drew him back to the grim prison of his youth to paint another *Beggar's Opera*. This time the spectators are the Committee, witnessing the confrontation of the warden and his wretched prisoners. Thornhill was an MP and may have helped Hogarth gain access to the committee; Hogarth was certainly spending time with Thornhill and his family, and as he was in the midst of the Fleet Committee painting he suddenly eloped with Thornhill's daughter Jane. The thought of a struggling engraver for a son-in-law apparently caused a temporary break with the angry father, but this was healed, according to one story, by the discreet exhibition of some of Hogarth's most recent paintings, and Thornhill seems to have helped his son-in-law establish himself as a fashionable portraitist.

Dozens of 'conversation pictures'—relatively small and cheap group portraits—demonstrated the fertility of Hogarth's brush in the early 1730s. Yet he still felt constricted: they were only portraits, they represented too much work for too little money, and work that was not suited to the genius of the engraver of *Hudibras*. Thus some of his conversation pictures included portraits of notorious contemporaries like Orator Henley and Justice De Veil, and others placed his sitters in roistering drinking parties; he was also available for 'special commissions' like the *Before* and *After* paintings. One oil sketch, which he displayed in his studio, showed a pretty young harlot's levée in her shabby Drury Lane quarters. The idea proved so fetching that he made a story about how she got there and what happened to her afterwards. Six paintings, with some contemporary portraits included, trace the history of a young person from the country who arrives in London, is lured by an old bawd with promises of affluence into keeping, and thence descends into prostitution, prison, disease, and death.

The momentous step, however, was the launching of a subscription for engravings of the *Harlot's Progress* paintings. Following the practice of other painters, including Thornhill, who had allowed their major works to be engraved and sold by subscription, he added one novelty: he dispensed with a printseller, managed the subscription himself, and kept all the profits; he also found soon enough that only he could adequately engrave his own paintings. The success of the venture was beyond his most sanguine expectations: nearly 2,000 sets were subscribed for at a guinea each, and their fame reached from the highest to the lowest, receiving the dubious compliment of many piracies.

His first response—as painter—was to pursue the patronage earned by this fame up to the royal family itself. But personal enmities (William Kent and the Duke of Grafton) and a backlash from the *Harlot* itself cut off the royal commission he had been prom-ised. (Imagine the Queen painted by the author of the *Harlot*!) His second, perhaps simultaneous, response was to paint another series—of eight this time, as if to go the *Harlot* one better—concerning the life of a young merchant's son who uses his inheritance to set himself up as a rake and squander his money, morals, freedom, sanity, and life. Other paintings followed by engravings, or 'modern moral subjects' as he called them (or 'comic history paintings' as his friend Henry Fielding was to call them) followed in rapid succession: *A Midnight Modern Conversation*, *Southwark Fair*, *The Distressed Poet*, *The Four Times of the Day*, and *Strolling Actresses in a Barn*.

In the midst of all this activity, however, he was diverted by another challenge. When he arrived on the scene foreign artists had dominated English portraiture since Van Dyck, if not since Holbein, and had suffered no competition in history painting until the rise of Thornhill. From personal contact with Thornhill Hogarth had inherited the English painter's hostility to foreign artists who took all the good commissions from native artists. Now in 1734 Jacopo Amiconi, the Venetian history painter, had secured, or was about to secure, a commission to decorate the new wing of St Bartholomew's Hospital. Only a stone's throw from Hogarth's birthplace, St Bartholomew's was a public institution about which he probably felt proprietary. He went to the treasurer, who was a friend, and offered to paint gratis an Englishman's version of sublime history. He produced the two huge panels that appear to this day along the stairway to the council chamber, illustrating Charity with *The Good Samaritan* and *The Pool of Bethesda*. He pursued other experiments at sublime history during the late 1730s. *A Scene from the Tempest* followed *Falstaff examining his Recruits* in illustrating Shakespeare, but now a sublime instead of a comic text. He persuaded his friend Jonathan Tyers to decorate his pleasure garden at Vauxhall with paintings and sculptures of contemporary subjects by native English artists, and contributed designs if not actual paintings himself.

The second challenge from abroad in the late 1730s was J B Van Loo, who arrived from Paris and quickly monopolised the portrait market, driving some English artists to bankruptcy. Hogarth responded by beginning to paint portraits himself, signing at least one 'W. Hogarth Anglus pinxt', and as usual focusing his efforts on a major show piece—a life-size, full-length portrait of his friend Captain Thomas Coram, founder of the Foundling Hospital. He was himself a founding governor, and he donated his finished portrait, knowing that it would hang on permanent exhibit in a public building, drawing attention to the English school of portraiture. In the 1740s he organised his artist friends to donate more portraits and a series of history paintings, establishing in the Foundling Hospital the first permanent public museum of English art. His own efforts at portraiture, however, did not sweep the board. Although he produced a great many single portraits between 1739 and 1745, only a handful of them were on the scale of the *Coram*, and these mostly of children, whom he was reputed to paint with wit and charm.

The decade of the 30s also saw Hogarth urging and passing an act to protect engravers like himself from the incursions of the pirates, and his founding an academy in St Martin's Lane for the guild-like banding together of English artists and the training of young artists (a step up, he thought, from the Painter-Stainers' Company to which Thornhill had belonged).

Based on the equipment he had inherited from Thornhill, he set up an academy, which was to train almost all English artists over the next thirty years.

In action as well as art the 30s represented a great burst of energy from a very energetic young man. He had opened up new sources of patronage, found permanent places for public exhibition of English paintings, had demonstrated the power and profit of reproducing one's own paintings in engravings and selling them by subscription (avoiding both printseller and private patron). He turned English painters to English history, Shakespeare and the classics, and actors playing on a stage, as well as to contemporary English scenes, as a source of inspiration equal to mythological and religious subjects. Almost singlehanded he opened the field of history painting to the English artist, himself inventing an intermediate form —the 'comic history'—which avoided while it ironically exploited the forms and subjects of sublime history, showing how literary, how allusive, paintingengraving can be. Thereby he founded a sturdily antiacademic tradition in England that would ensure, even at the height of Royal Academy prestige, the possibility of a Gainsborough, Constable, and Turner. He had led momentarily unsuccessful attacks on Van Loo and the foreign portraitists, but in the process he had laid the groundwork for the English school of Reynolds and Gainsborough.

Of course, he did none of this alone. He was not free of outside, often academic, even foreign influences. Gravelot was probably responsible for much of his developing aesthetic, and Hayman certainly contributed to the growth of native history painting. But in every case Hogarth was the man in the centre— the one who initiated, acted, and exemplified in his own work. He was also, to be sure, a self-publicist whose mastery of the engraved medium ensured him of the limelight, and whose publicising of himself took ever more personal forms as he aged, and as he thought he saw his life work being eroded by the new generation.

In the early 1740s, while still painting portraits, he began to plan a new 'comic history' cycle, this time of high life and making the most extravagant claims to date for his new mode. *Marriage à la Mode* was to have French engravers (who, he felt, could give the subject an appropriate elegance his own engraving could not), for which he made his first trip to Paris. The outbreak of war with France delayed, but did not cancel, these plans, and both paintings and plates were the most finished (if not over-finished) he produced. The year 1745, when he published *Marriage à la Mode*, also saw his official self-portrait with his alter-ego Trump, which he engraved as frontispiece to the bound volumes of his engravings he was now selling; and an auction of his paintings-for-engravings, without the interference of picture dealers, whom he regarded together with patrons and printsellers as outmoded relics of a time before English painters had come of age.

He does not seem to have been happy about the prices he received for his series of six or eight paintings —little more than the price for a single painting. At any rate, he suddenly abandoned paintings for histories and turned to drawings, and a cruder, simpler style of engraving, addressing himself to a lower and larger audience which had little interest in oil or history painting: merchants down to shopkeepers, their servants and clerks, apprentices, porters, and sedan-chairmen. *Industry and Idleness*, *Beer Street* and *Gin Lane*, and *The Four Stages of Cruelty*

were aimed at the men who had authority for the poor, but the plates undoubtedly reached the poor themselves, who (though they could not afford to buy) saw them in shop windows, in coffee houses, and in the houses of their masters.

But Hogarth was also doing something positive. Up to this point he was a designer and printmaker of unsurpassed intellectual subtlety, whose work can be appreciated only in the company of Swift, Pope, and Fielding. He had carried this 'readable' structure of meaning as far as, if not further than, it could legitimately go in *Marriage à la Mode*. He now radically reduced the complexity, denotation, and allusion, and showed how pictures can be organised around simple formal structures like his Serpentine Line, and replaced (to the best of his abilities) the readable with an expressive structure in which meaning emerges from shapes, relationships between size and shape, and emblems either submerged or blown up into a single powerful image. But in a sense the six large popular prints he issued in February 1751, *Beer Street*, *Gin Lane* and the *Stages of Cruelty*—upright instead of the usual horizontal style—were the most striking 'histories' of his career. They employed crudely popular themes and forms as a way of battering the connoisseurs and the conventions of polite art, making claims for a more elemental, deep-rooted art.

The simplification of structure is first evident in the monumental portrait of *Garrick as Richard III* he painted just after completing *Marriage à la Mode*. Here the busy detail of his earlier paintings is reduced to a simple close-up of the long S of Garrick-Richard's body as it twists in agony and terror. He may also have come at this simplification of form through his years of portrait-painting; the great portraits of the 1740s—Hoadly, Herring, the McKinnon and Graham Children—anticipate the monumentality of the histories he painted for the Foundling Hospital and Lincoln's Inn, *Moses brought to Pharaoh's Daughter* and *Paul before Felix*. The new development was also accompanied by an attempt to paint another series— this time a *Happy Marriage*—that did not get beyond a series of oil sketches. In these brilliant works incident is reduced to a minimum, and representation and conventional finish are never allowed to emerge from the play of pure form and colour in the action of paint on canvas. These were sketches which, he must have realised, could never be finished: in their unfinished form, as purely expressive structures of paint, they represent the most forward-looking aspect of Hogarth's art. They are reflected in the delicate balance of finish and roughness in his next modern history, *The March to Finchley*, which sums up his career to this point—and was not to be surpassed thereafter.

At the same time that he was carrying out these experiments in form and its relation to expression and meaning, he was also talking, generalising, weaving theories, and in about 1751 he began to put his thoughts down on paper. The result, *The Analysis of Beauty*, published at the end of 1753, was the first formalist art treatise in English—a remarkable document to come from the pen of the author of *A Harlot's Progress* and *Marriage à la Mode*. He was in effect illustrating his change of style in the subscription ticket and two different engraved versions of *Paul before Felix*, which he brought out (with an engraving of *Moses*) about the time he announced his subscription for the *Analysis*.

Hogarth had never hidden his light under a bushel: he had not only achieved great popularity, great fame of a sort, but he had become relatively rich,

had gathered public benefits for other artists as well as himself, and had done a great deal of talking about himself in relation to Van Dyck and Raphael. Now he had written an art treatise! Moreover, at just this moment the younger generation, with some of Hogarth's contemporaries and friends, was trying to found a real state academy of art—against Hogarth's bitter opposition. The *Analysis*, basically anti-academic as was everything about Hogarth, must have seemed a clarion call of defiance. The result was that its appearance was greeted with attacks in verse and caricature, and Hogarth was called arrogant, plagiarist, fool, and madman; as his written notes of a decade later show, he was deeply shocked and offended.

In the middle of all this fuss, in early 1754, he began to advertise his last ambitious series, four paintings of an election. This involves larger canvases and more figures, but in simpler, less rococo patterns of confusion; Lines of Beauty define and hold the scenes together as they did *Garrick*, *Moses*, and *Paul*. Though the paintings were probably finished when he announced his subscription, the engravings, proving more difficult than usual and the problem of engravers worsening, were not all published until 1758.

In the interim Hogarth fulfilled his one ecclesiastical commission—the three large panels for St Mary Redcliffe, Bristol; became Serjeant Painter to the King; and returned in a limited way to portrait-painting. But the great events—reflected in the engravings and revisions of the *Election*—were the loss of English prestige, the early disastrous engagements of the Seven Years War, and a general sense of disillusionment in English politics. The last half of the decade was a time of falling off in productivity, and letters of the time show Hogarth, just turned sixty, a tired and ageing man. In 1757 he announced in one of his despairing advertisements about his troubles with engravers that he was through with comic histories and modern moral subjects; he would devote the remainder of his life to the less demanding production of portraits.

Hogarth, however, was never one to avoid a challenge, and the challenge came when his young friend the Earl of Charlemont commissioned one last comic history, which became *The Lady's Last Stake*, a simple composition of two people in comic-sentimental tension. Seeing the picture, Sir Richard Grosvenor, one of the richest young men in England, was so pleased that he asked Hogarth to paint him one too: which Hogarth took to mean on the same conditions as the Charlemont picture. He had been outraged by the price fetched at auction by a 'Correggio' *Sigismunda*, which he doubted was even a Correggio. With Grosvenor's offer at hand, he decided to make his own version, asking at least as much as the 'Correggio' brought. The result was an interesting experiment—and the first of a long line of suffering females that passed for history painting in England, and a yet more simplified composition for Hogarth. Only Sigismunda's torso appears, the goblet, her lover's heart, and the table.

The picture seems to have given him trouble, and too much friendly—and not so friendly—advice led him to pass too far beyond the freedom of a sketch to finished and over-finished representation. Grosvenor, at any rate, had no use for a picture of a woman weeping over her lover's heart, and he had probably also gotten wind of the critical comments flying about. He extricated himself from the bargain with the masochistic assistance of Hogarth himself, who followed with a poem on the subject and much talk over drinks with his friends, an attempt at vindication by having the picture engraved and sold by subscription, and the filling of his subscription book with Grosvenor's and his own letters on the subject.

His art almost ceases at this point. The last four years are years of illness, some bitterness, and uneasy withdrawal that broke off for one last burst of concerted energy. A few portraits are the only known paintings of these years, and the only significant action his joining the Society of Artists' exhibit of 1761 (but with no new canvases). The next year he withdrew again, organising and designing a mock-exhibition of English art, the Sign-painters' Exhibition, of which, unfortunately, no traces remain.

What brought him back were (he said) the need for money and the bitter attacks by his countrymen, including some old friends, on the new king, George III, his first minister, even his mother, and the desire for an end to the Seven Years War. When the attacks were augmented in the summer of 1762 by his friend John Wilkes' *North Briton*, Hogarth responded—in spite of warnings from Wilkes—with an emblematic print, *The Times, Plate 1*, which showed Pitt and the City merchants fanning the flames of war, and the loyal fire-fighters hindered by the activities of the Pittite propagandists (which included Wilkes and Charles Churchill). The response to *The Times* was immediate and worse than that following the *Analysis*. He was called a placeman (since he was Serjeant Painter), a hireling, a traitor to his friends and former beliefs, and a senile, demented old man. He showed that he was not yet to be counted out; he responded to Wilkes' attack in *North Briton* No. 17—though his lines are now shaky—with a wonderful caricature of the demagogue at the hearing over his seditious No. 45.

He suffered a serious physical relapse shortly after the initial attacks on *The Times*, and again during the following summer; an unfinished *Times, Plate 2*, suggests that he had become as disillusioned with the Earl of Bute's loyal ministry as with the Pittites; and after his response to Churchill's *Epistle to William Hogarth* with *The Bruiser* he simply withdrew, wrote notes toward an autobiography justifying his career and a commentary on his moral works, made corrections and strengthened the lines of his plates, and prepared for death. His last print, issued six months before his death, was a *Tailpiece, or the Bathos* to finish off his volume of prints; it reflects the darkened view he held by this time of the world and his own place in it, but cheerfully continues to speculate on the utility and significance of his Line of Beauty.

Catalogue and Commentary

by Lawrence Gowing

Dimensions are given in inches. Height precedes width.

Hogarth's work has been catalogued in the following books: R B Beckett, *Hogarth*, London 1949; A P Oppé, *The Drawings of William Hogarth*, London 1948; Ronald Paulson, *Hogarth's Graphic Works*, New Haven and London 1965, revised edition 1970. The standard biography, illustrating works not listed elsewhere, is now Ronald Paulson, *Hogarth: His Life, Art, and Times*, New Haven and London 1971. Quotations not otherwise ascribed are from Hogarth's *Autobiographical Notes* (British Museum, Add. Ms. 27, 991; Eg. Ms, 3015, ff. 7–11). These have been published by Joseph Burke, together with *The Analysis of Beauty* (Oxford 1955). They are here edited for easy reading. Hogarth's *An Apology for Painters* has been edited and published by Michael Kitson (Walpole Society, XLI, 1966–8).

Dates between 1 January and 25 March, on which the old style year began, were quoted in both old and new styles thus, 1734/5, until the Calendar Act of 1751. States of prints are numbered according to the revised edition of Paulson's catalogue; earlier numberings are in some cases indicated on the mounts of exhibited impressions.

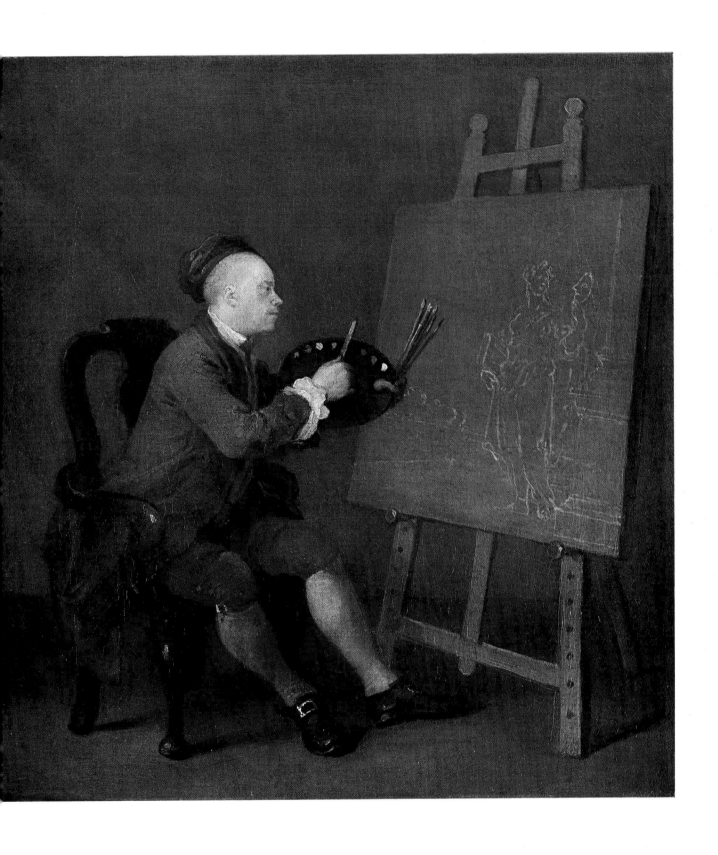

Hogarth Painting the Comic Muse
circa 1758 (137)

Beginnings

Hogarth's originality showed itself first as a continual impatience. Apprenticed to a silver-plate engraver, 'the Narrowness of the business', as he later explained, 'determined me on engraving no longer than necessity obliged me to it'. At twenty his ambition ran to trade cards and book illustrations on copper plates, but for them 'drawing objects something like nature, instead of the monsters of heraldry, became necessary. To attain this', he confessed forty years afterwards, 'the common methods were much too tedious for one who loved his pleasure and came so late to it'. As a craftsman he laboured under the same disadvantage. 'As to engraving, the bad habits got by his former business, together with his impatience prevented his attaining that beautiful stroke on copper which is acquired by early habit and great care.' Artists gain a good deal of self-knowledge; Hogarth realised what the basic trouble had been: 'fine engraving . . . is scarcely ever attained but by men with a quiet turn of mind'. No one ever credited him with that. Thornhill's great decorations, which were running in his head—the greatest successes that an Englishman had ever scored against the competition from abroad—were disturbing examples for a journeyman. This was the situation, as he saw it later, that 'made him turn his head to painting'.

No artist has given a franker account of his motives than Hogarth. 'As my time was chiefly lost till I was three and twenty in a business that was rather detrimental to the arts of Painting and Engraving I have since pursued, I was naturally (as I could not help prizing the time best suited to the common enjoyments of life) thrown upon an enquiry after a shorter way of attaining what I intended to aim at than that usually taught among artists. Having first considered what various ways and to what different purposes the Memory might be managed, I fell upon a method I thought most suitable to my situation and Idle disposition, which was to make my studies and my pleasures go hand in hand by retaining in mind *lineally* such objects as fitted my purpose best'. Jettisoning the traditional routine, he set about his highly original programme of self-education, ' . . . retaining whatever I saw in such a manner that by repeating in my mind the parts of which objects were composed I could by degrees put them down with my pencil . . . only trying now and then upon my canvas how far I was advanced by that means'. All that now remains of Hogarth's mnemonic linear system is the row of matchstick men which he included in the second plate to the *Analysis of Beauty* to demonstrate how he set out 'The Dance'. The documented pictures painted when he was about 31 show the training to be complete and until lately nothing was known of the occasional and tentative paintings of the years between 1721 and 1728. The first three paintings in the exhibition fill the gap better than anything else that has emerged so far. If, as is likely, they are Hogarth's, the pronounced, inelegant angles with which these men use a pick or a plane is, in the light of his method, easy to understand.

The method set him, as he wrote, 'upon remarkable and striking subjects'. His impatience with the traditional routine—'the common methods of copying and drawing'—was an instinct for art as a way of life. His intention echoes through his notes—'to make my studies and my pleasures go hand in hand'. This predisposition preserved, almost throughout his work, a feeling for the everyday meaning of things and a commitment to what naturally concerns a man. He retained a frame of mind in painting as quick to laughter, to sympathy or to indignation as in life. It was due to him that the territory which Thornhill had won for English painters was occupied not by the stylistic juggernauts of continental art but by men of feeling. An image by Hogarth is compiled from elementary and literal observations which are knitted into a fabric of human incident more diverse and diverting than anything in art before. In pictures like 'The Christening' we become aware that for him a domestic scene encloses a whole human spectrum, through affectation, pretence, deceit and greed, between vulnerable innocence and vice.

1 **Hogarth's Shop Card** Published 23 April 1720
Engraving, $3 \times 3\frac{5}{16}$. *Trustees of the British Museum*

2 **The South Sea Scheme** 1721
Pencil, $8\frac{1}{2} \times 9\frac{3}{4}$. *Her Majesty The Queen,
Royal Library, Windsor*
Study for the engraving of 1721.

An allegory of the mania for speculation attending the South Sea Bubble, which had burst in the autumn of the year before. The wheel of fortune, which dominates the design, is an echo of the execution tree in Callot's 'La Pendaison'. The relevance of the wheel and whipping post, beloved by popular allegorists, is here not immediately apparent and the caption explains that they illustrate.

> *The woeful Cause yt in these Times,*
> *Honour and Honesty are Crimes*
> *That publickly are punished by*
> *Self interest and Vilany . .*

The crowd, which is barely indicated in the drawing, was developed in the print to give a first glimpse of Hogarth's vivid characterisation of current life.

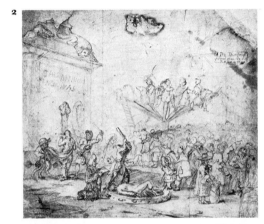

3 **The Lottery** *circa* 1724
Black ink over pencil with wash and corrections in brown ink and red chalk, $9 \times 12\frac{3}{4}$. *Her Majesty The Queen, Royal Library, Windsor*
Finished study for the engraving published in September of 1724.

Under the incongruous presidency of National Credit the fortunes and consequences of the state lottery, which was a controversial feature of the economy throughout the eighteenth century, are ranged as if on a stage. The groups show a series of alternatives, on the model of the choice of Hercules. To the left, Good Luck on his dais must choose between Pleasure (abetted by Folly and Lust for Gold) and Fame, who indicates the neglected Virtue of philosophy and art (borrowed by no means satirically from 'The School of Athens'). To the right Misfortune who has drawn a blank is oppressed by Grief and supported by Minerva, who points out the charms of Industry. In the middle Suspense is turned to and fro by Hope and Fear. 'The Lottery' shows relatively little of the energetic observation which appeared in 'The South Sea Scheme' engraving; it was produced later as a companion piece.

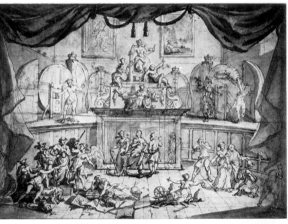

4 **The Taste of the Town**
Published February 1723/24
(a) First State (b) Second State
Etching and engraving, $5 \times 6\frac{11}{16}$. *Trustees of the British Museum*
On the left a satyr and a clown rope in the fashionable crowd to the Italian opera, masquerades organised by a Swiss and a conjuring display. Opposite the audience presses in to see a harlequinade of Dr Faustus, while the works of the great British writers from Shakespeare to Addison are carted away as waste paper. The background illustrates the same exotic tastes in the fine arts. Over the gate of Burlington House (inscribed with uncanny prescience 'Accademy of Arts') Lord Burlington's protegé Kent is elevated above Raphael and Michelangelo.

Hogarth described how 'the first plate I published, called the Taste of the Town, in which the then reigning follies were lashed, had no sooner begun to take run but I found copies of it in the printshops selling for half the price whilst the originals were returned to me again. I was obliged to sell my plate for what these pirates pleased to give me, as there was no place of sale but at their Shops'.

13

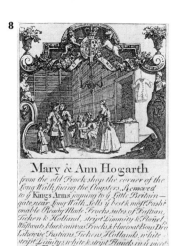

8

Mary & Ann Hogarth

from the old Frock shop the corner of the Long Walk facing the Cloysters, Removed to y Kings Arms joyning to y Little Britain gate, near Long Walk. Sells y best & most Fashionable Ready Made Frocks sutes of Fustian, Ticken & Holland, strip't Dimmity & Flanel Wastcoats, blue & canvas Frocks, & blue cod Boys Dra Likewise Fustians, Tickens, Hollands, white strip't Dimitys, white & strip't Flanels in y piece by Wholesale or Retale at Reasonable Rates

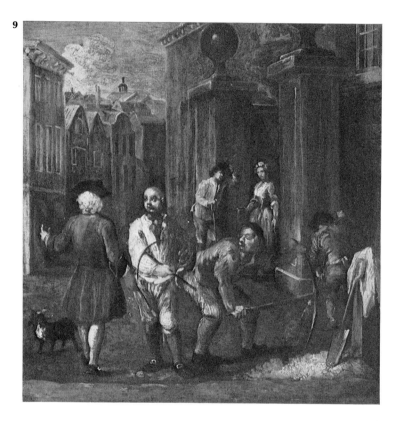

9

10

5 **Impression from a Tankard belonging to the Clare Market Actors' Club** *circa* 1724
Impression from engraving on plate, $4\frac{1}{4} \times 6\frac{1}{2}$.
Victoria and Albert Museum
Painting and Sculpture frame a scene with Laban and his sheep (Clare Market was a meat market).

6 **Royalty, Episcopacy and Law** Published December 1724
Etching and engraving, $7\frac{1}{4} \times 7$. *Trustees of the British Museum*
Emblematic objects assembled in human likenesses in the mannerist tradition, with a characteristic message regarding the mechanical heartlessness of authority. The scene is the moon, a common location for the lunatic extremes of eighteenth-century satire, viewed as if through a telescope.

7 **A Just View of the British Stage**
Published 10 December 1724
(a) First State
(b) Second State
Etching and engraving, $7\frac{1}{8} \times 8\frac{3}{8}$. *Trustees of the British Museum*
Advertised by Hogarth as 'A print representing the rehearsals of a new Farce, call'd three Heads are better than one . . . ' The three managers of the Theatre Royal, Drury Lane, are shown planning to outdo the Harlequinades of John Rich. Colley Cibber dangles a figure of Punchinello and calls on the Muses for aid. The latest of the harlequins, who have eclipsed Comedy and Tragedy, are modelled on the notorious criminals of the day, celebrating their comic escapes from prison. Ben Johnson rises from his grave. The style is simplified in imitation of a popular broadsheet.

8 **Hogarth's Sisters' Shop Card** *circa* 1730
Etching, $3\frac{5}{8} \times 4\frac{1}{8}$. *Trustees of the British Museum*

9 **Sign for a Paviour** *circa* 1725
Panel, 22×22. *From the Collection of Mr and Mrs Paul Mellon, Upperville, Virginia*

10 **Sign for a Paviour** *circa* 1725
Photographs of etchings by Jane Ireland, 1799
The ascription of the small group of early paintings depends on their resemblance to this sign board. The whole board was in the collection of Samuel Ireland, who included both sides in the *Graphic Illustrations*. The two faces were later sawn apart and only one in the collection of Mr and Mrs Paul Mellon is known. Charles Catton (1728–1798) who vouched for its authenticity was a founder-member of the Royal Academy and an interesting artist (he exhibited an 'Emblematic Picture of Reason' in 1761). He was also a coach-painter; when Hogarth set up his coach it was decorated with the device of Variety by Catton. Hogarth is as likely to have talked to him as to anyone about the journeyman's work in which he seems, like Catton, to have found his feet as a painter. All Hogarth's townscapes testify to his interest in signboards. The mocking implication that the Grand Exhibition of Sign Painters, which he inspired in 1762, was worth as much consideration as the Society of Artists was not entirely ironic. A paviour very similar to the bending figure in this sign reappeared in the background of 'Beer Street' 25 years later.

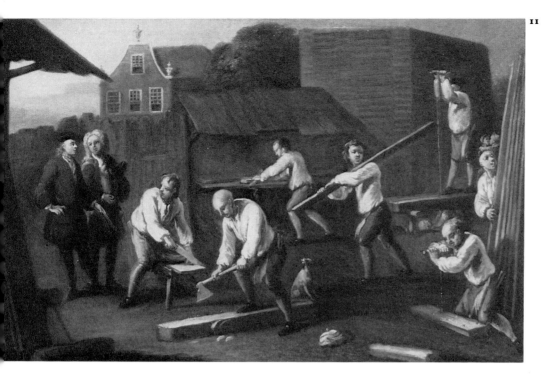

The Carpenter's Yard *circa* 1725
Oil on canvas, 23½ × 37. *Sidney F Sabin, Esq*
lthough the style is more finished, the relationship to
e 'Paviour's Signboard' is close. The subject is again
 trade; indeed the three pictures give the most de-
iled view of conditions of work in the early eighteenth
ntury that we have. The figures combine traditional
uotations with surprising realism; nowhere else is
e defiant baldness of middle-aged heads in the
eriod of perukes so sharply observed. The gentlemen
ho stop to watch the work in these pictures imply
 very precise sense of class distinction and there is
erhaps an indication of the painter's ambition; the
rofile of the young man in the hat is quite like that
hich in later pictures represented Hogarth himself.
he clumsy architecture, oddly intractable to per-
ective, long remained characteristic of Hogarth.

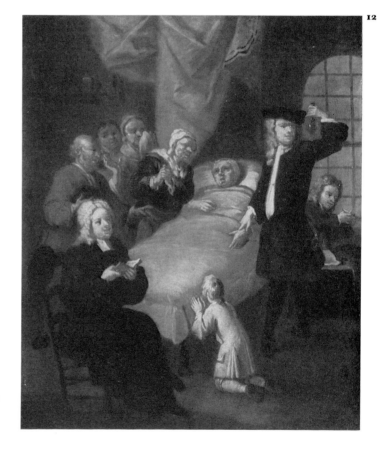

The Doctor's Visit *circa* 1725
Oil on canvas, 29³⁄₁₁ × 24½. *Tate Gallery*
he sickbed scene with a doctor scrutinising his lady
atient's urine was an old Dutch subject, rarely with-
ut a scabrous suggestion. Here the scope is broader;
 includes not only the trades of lawyer and parson
ut a whole range of social and emotional differentia-
on appropriate to the serious drama of a deathbed.
Iuman detail is described with a surer touch not far
om Hogarth's manner in later pictures; the sense of
ale remains uncertain. The existence of a replica in a
oarse form of his style a few years later is further
vidence of his authorship.

A Garret Scene *circa* 1726
Red chalk, 9½ × 13. *Trustees of the British Museum*
his drawing, the first indication of Hogarth's interest
 the subject of the Harlot, seems to be near in date to
Iudibras'. A jovial, disease-ridden whore, attended
 y her villainous servant, is discovered in a setting that
ten reappears in Hogarth's work. The drawing may
ive been made for an illustration, though it is
ld that it should be squared instead of incised if it
as to be engraved. The figure, with its pronounced
igular formation and its disproportion, has points of
semblance to the early paintings and it may be that
is was another trade which Hogarth intended to
int.

Drawings for Hudibras 1726
Her Majesty The Queen, Royal Library, Windsor

14 **Frontispiece**
Pencil with grey-black ink, brown and grey washes, $9\frac{1}{2} \times 13\frac{5}{8}$

15 **Hudibras Sallying Forth** (For Plate 2)
Red chalk with touches of black, $9\frac{1}{2} \times 13$

16 **Hudibras' First Adventure** (For Plate 3)
Brush drawing in grey, $9\frac{1}{2} \times 13\frac{3}{4}$

17 **Hudibras Encounters the Skimmington**
(For Plate 7)
Brown ink over pencil heightened with white, $9\frac{3}{4} \times 17\frac{1}{8}$

17

18 **The Burning of the Rumps at Temple Bar**
(For Plate 11)
Brown ink with washes, $9\frac{3}{4} \times 8\frac{3}{8}$

19 **Hudibras and the Lawyer** (For Plate 12)
Brown ink with brown and grey washes, $9\frac{5}{8} \times 13\frac{1}{4}$
Finished studies for six of the twelve large engravings for Samuel Butler's *Hudibras*. These evidently developed out of a series of small plates which Hogarth adapted from existing illustrations for an edition of the poem whose publication was delayed until after the larger series. Butler's mock-heroic poem, modelled on *Don Quixote*, describes a pedantic Presbyterian setting forth 'a-colonelling' with his squire, an Independent. The objects of the satire are the hypocrisy of the Puritans, their sectarian quarrels and incomprehension of common life. The style, which combines a vernacular seventeenth-century manner with mock-heroic echoes, appropriately characterises Hudibras' obtuse heroic pose. The Skimmington, with which Hudibras tries in vain to interfere, was a popular procession mocking a cuckolded husband; it is ironically rendered as a Baroque triumph, with a reference to the erotic apotheosis of Bacchus and Ariadne in the Farnese Gallery. The Burning of the Rumps celebrated popular dislike of Puritanism and the Rump Parliament at the Restoration; Hudibras is burned in effigy.

20 **The Theft of a Watch** *circa* 1727
Oil on canvas, $14\frac{1}{8} \times 12\frac{1}{4}$. *Visitors of the Ashmolean Museum, Oxford*

20

21 Henry the Eighth and Anne Boleyn
circa 1728–9
Etching and engraving, First State, $17\frac{3}{8} \times 14\frac{5}{16}$.
Trustees of the British Museum

Evidently suggested by Colley Cibber's production of
Henry VIII at Drury Lane on 26 October 1727,
although the print does not show any scene in the play.
The parallel between Wolsey and Walpole was
generally noted and the prominence of Wolsey in the
print, as well as the arrangement of the verses in the
first state, was clearly intended to support the Opposi-
tion's hope that a similar fate could be foreseen for the
Prime Minister. A painting of the subject decorated
the pillared saloon at Vauxhall Gardens until the
1740s, no doubt with Hogarth's approval; it may have
been copied from the print. Horace Walpole, who
saw it, denied that it represented the Prince of Wales
and Harriet Vane. The rumour was nevertheless
current (a satire on the Prince's marriage in 1736
borrowed Hogarth's composition) and, in the circum-
stance of the Prince's patronage, must have been em-
barrassing enough to cause the disappearance of the
picture.

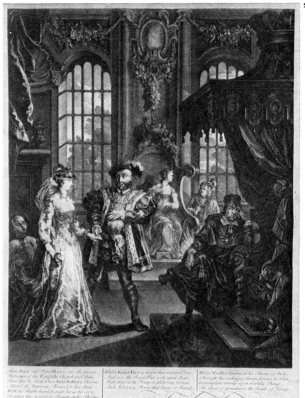

22 The Walpole Salver 1728/9
Engraving on plate, $15\frac{1}{2} \times 15\frac{1}{2}$ (weight 135 oz).
Victoria and Albert Museum

23 The Great Seal of England 1728–9
Impression from engraving on plate, Second
State, $15\frac{1}{2} \times 15\frac{1}{2}$. *Trustees of the British Museum*

The last and finest example of Hogarth's works as an
engraver of plate. Hercules, victorious over Envy and
Calumny, is shown supporting the two faces of the
Great Seal of George I. On the death of a monarch
the Chancellor of the Exchequer was entitled to retain
the silver matrix of the Great Seal and have it made
into plate, earlier usually a cup and later a salver.
The goldsmith in this case was Paul de Lamerie but
Hogarth was probably chosen by Sir Robert Walpole
himself, who had been the object of his attacks and
needed to appease him.

24 The Sleeping Congregation *circa* 1728
Oil on canvas, $21 \times 17\frac{1}{2}$. *Minneapolis Institute of
Arts (Gift of Mrs Lyndon M King)*

The earliest painting in which the intention is openly
satirical. The design occupied Hogarth over a longer
period than any other. This sketch, elaborated a little,
was engraved in 1736. The clerk, asleep in the paint-
ing, is awake in the print and eyeing the deepened
décolletage of the girl. This plate was 'Retouched
and Improved by the Author' in April 1762, when the
design provided the foundation for the elaborate satire
on Methodism conceived as 'Enthusiasm Delineated'
and published as 'Credulity, Superstition and Fanati-
cism'. The sketch is not dated as such, but the date
inscribed on the plaque is probably reliable.

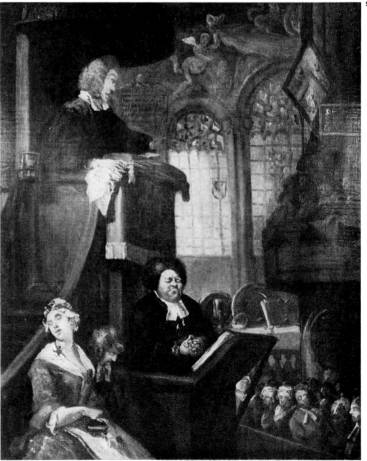

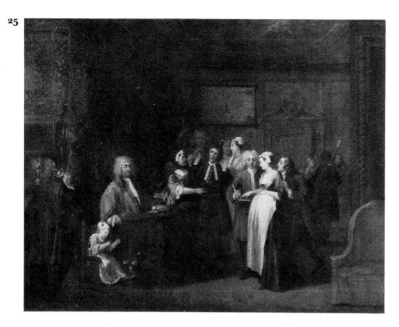

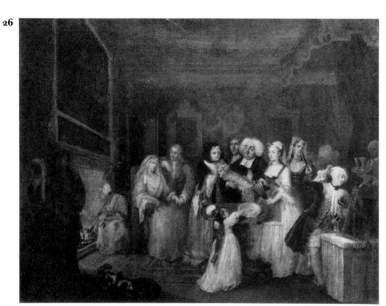

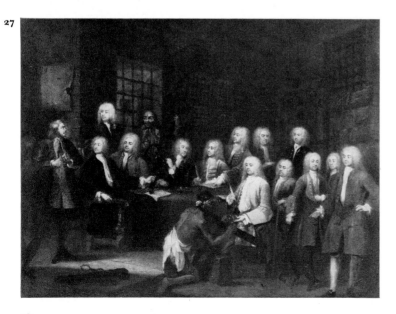

25 **The Denunciation** *circa* 1729
 Oil on canvas, 19¾ × 26. *National Gallery of Ireland
 Dublin*
Engraved a few years later by Joseph Simpson Junio
as 'A Woman swearing a Child to a grave Citizen'.

26 **The Christening** *circa* 1729
 Oil on canvas, 19½ × 24¾. *Private Collection*
The father preoccupied with his vanity, the mother
accepting another man's attentions, the divine with
eyes only for the girl beside him, the careless child
the stiff spinster and the nurse by the fire introduc
typical motifs of later pictures. The ceremony is
performed by Orator Henley, an eccentric and
notorious preacher who had broken with the church in
1726 in order to set up his own establishment, charg
ing for admission.

27 **The Committee of the House of Commons**
 1729
 Oil on canvas, 20 × 27. *National Portrait Gallery*
Conditions in the Fleet prison came to light when the
oppressive exactions of the Warden, Thomas Bam
bridge, drove Sir William Rich, an inmate, to stal
him. The committee appointed to investigate ex
amined Bambridge on 8 March 1728/9. Hogarth'
entrée to the scene may have been arranged by
Speaker Onslow, who commissioned a picture from
Thornhill in which he collaborated, or by Thornhill
his father as a bankrupt had been a prisoner in the
Fleet twenty years before. Onslow is recognisable
among the members, together with Walpole and the
Chairman, Oglethorpe, who had taken up the
complaint; the members also included John Thomson
who later commissioned 'Before' and 'After'. A version
of the picture was bought by William Huggins, son of
the previous Warden who had made his own fortune
before selling the office to Bambridge.

Conversation Portraits

'Dissatisfaction with engraving, Hogarth explained, made him turn his head to painting portrait figures from 10 to 15 inches high, often in subjects of conversation. It had some novelty . . . it gave more scope to fancy than the common portrait . . . '. The description of the advantage that the new style held for him is unexpected and without a parallel until Goya's explanation of pictures that he painted some 60 years later. 'A Children's Party' and 'The House of Cards', in spite of their technical naivety—indeed largely because of the freshness of approach to the sophisticated form—are in fact more subtly allusive and more natural than the continental examples from which they derive. The provincial innocence of this manner may have prevented it from producing a masterpiece, but it was nevertheless a considerable invention on which British painters drew for 50 years. These pictures appealed to men of taste who were coming to terms with the Rococo style. Hogarth never enjoyed such elegant patronage again. But there was also something innocent in his expectation that he could both satirise the establishment and serve it. Having allied himself with Thornhill, he necessarily shared in Thornhill's defeat. The double rebuff to his ambition as a court portraitist in 1733 marked a turning-point in his career. Henceforward the patrons for his paintings were bourgeois or eccentric. His distrust of fashionable cosmopolitan taste was confirmed and the sardonic independence of his view developed unchecked.

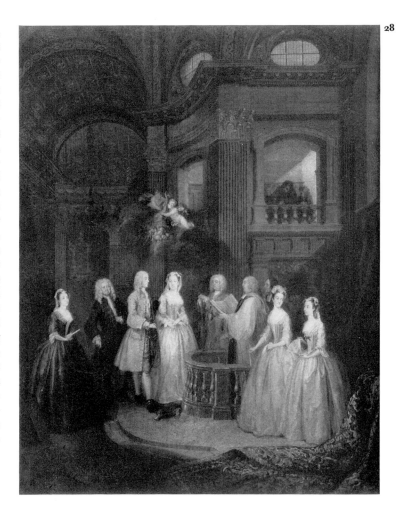

28

28 **The Wedding of Stephen Beckingham and Mary Cox** 1729–30
Oil on canvas, $50\frac{1}{2} \times 40\frac{1}{2}$. *Metropolitan Museum of Art, New York (Marquand Fund, 1963)*
The wedding of Stephen Beckingham of Lincoln's Inn and Mary Cox from Kidderminster is shown in St Martin in the Fields though it did not in fact take place there. Inscribed 9 June 1729, the date of the wedding not the picture.

29 **Assembly at Wanstead House** 1729–31
Oil on canvas, 25 × 30. *Philadelphia Museum of Art (John Howard McFadden Memorial Collection)*
Sir Richard Child, Viscount Castlemain, with his wife, children and guests in the magnificent hall of the house that he had lately built at Wanstead Manor in Essex, bought by his father, the corrupt and despotic chairman of the East India Company.

30 **The Wollaston Family** 1730
Oil on canvas, 39 × 49. *Trustees of the late H C Wollaston*
William Wollaston (1693–1764) of Finborough Hall, Suffolk, with his wife Elizabeth Fauquier, whom he had married in 1728, and 13 of their relatives. The scene is probably his house in St James's Square. The silvered tea-table, of a type of which no examples have survived, appears in many of Hogarth's conversation pieces. Praised by Vertue in December of the same year: '. . . this is really a most excellent work containing a true likeness of the person, shape aire & dress—well disposed. genteel, agreable.—& freely painted & the composition great variety & Nature.'

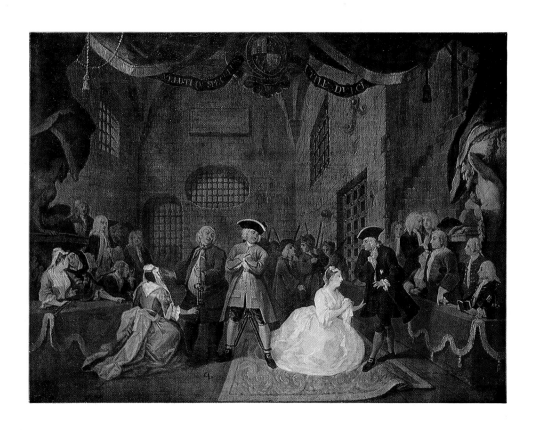

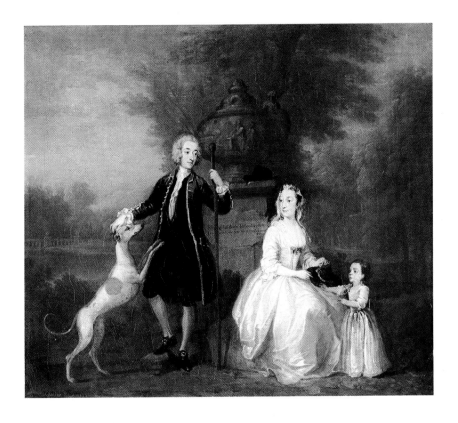

The Beggar's Opera VI
1729–31 (47)

Ashley Cowper with his Wife and Daughter
1731 (35)

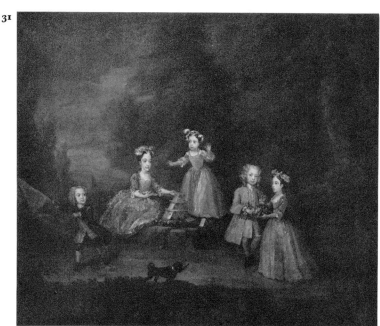

31

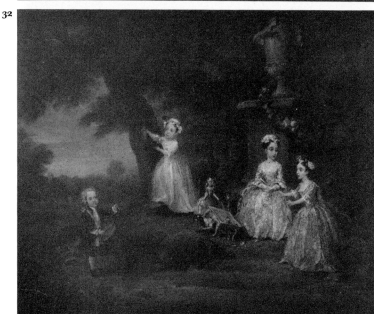

32

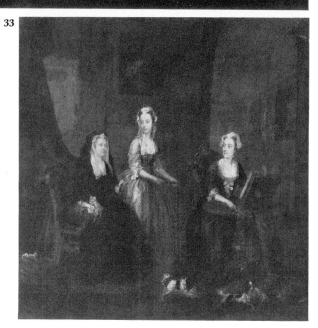

33

31 **The House of Cards** 1730
Oil on canvas, 25 × 30. Signed and dated. *Private collection*

32 **A Children's Party** 1730
Oil on canvas, 25 × 30. Signed and dated. *Private collection*

Both pictures make delicately ironic play with allegories of vanity and fortune. The children's games—mimic warfare and precarious domesticity—the dog that imitate them and the chances that imperil a card-house or upset a tea-table intimate that the follies of childhood are those of mankind. The upset table reappeared several times in Hogarth's work; it figures in the second plate of 'A Harlot's Progress'.

33 **The Broken Fan** *circa* 1730
Oil on canvas, 27 × 27. *Private collection*

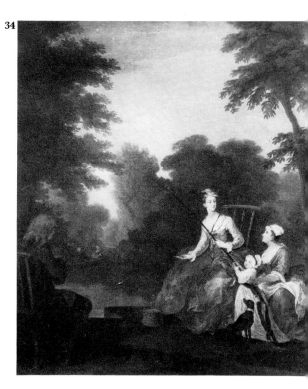

34

34 **A Fishing Party** *circa* 1730
Oil on canvas, 21⅜ × 18½. *Governors of Dulwich College Picture Gallery*

35 **Ashley Cowper with his Wife and Daughter** 1731
Oil on canvas, 21 × 23⅞. Signed and dated. *Tate Gallery*
(Reproduced in colour on p21)

Ashley Cowper (1701–1788) a barrister, Clerk of the Parliaments and William Cowper's uncle, was a close friend of Hogarth. The small girl was born in 173 and added to the picture later.

36 **Monamy Showing a Picture to Mr. Walker**
circa 1730–2
Oil on canvas, 24¾ × 20. *The Earl of Derby, MC*
The sea-piece on the easel is by Monamy himself.
Thomas Walker was a commissioner of customs
whose collection of Dutch and Italian pictures was
admired by Vertue in 1748.

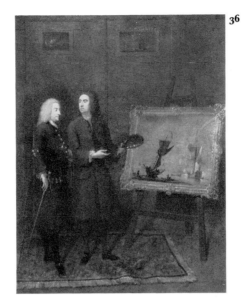

37 **The Fountaine Family** *circa* 1730–2
Oil on canvas, 18¾ × 23½. *Philadelphia Museum of
Art (John Howard McFadden Memorial Collection)*
Sir Andrew Fountaine, Vice-Chamberlain to Queen
Caroline and Warden of the Mint, was one of the best
known collectors of his time. According to the
younger Richardson, 'he out-Italianised the Italians
themselves' and the sophistication of the setting re-
flects his tastes. The picture with its punning reference
to his name is shown by his son-in-law Christopher
Cock, the auctioneer.

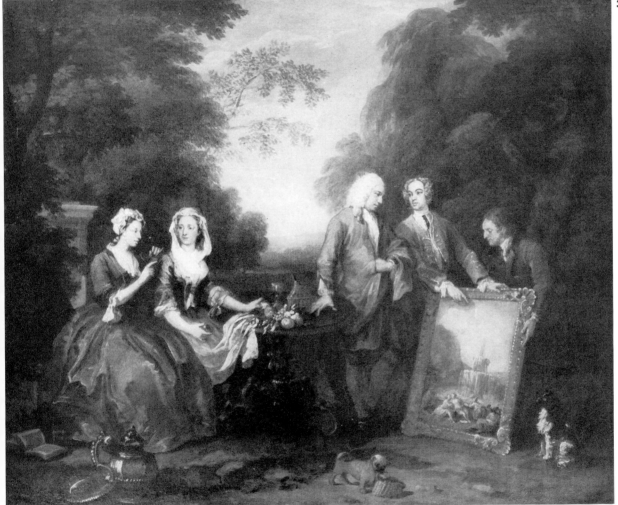

38 **H.R.H. William Augustus, Duke of
Cumberland** *circa* 1732
Oil on canvas, 17½ × 13½. *Private collection*
Third son of George II, born in 1721; future victor of
Culloden. The separate portrait is possibly the out-
come of a sitting given in connection with 'The
Conquest of Mexico'. Prince William also appears
in the group of 'The Royal Family.'

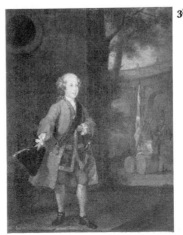

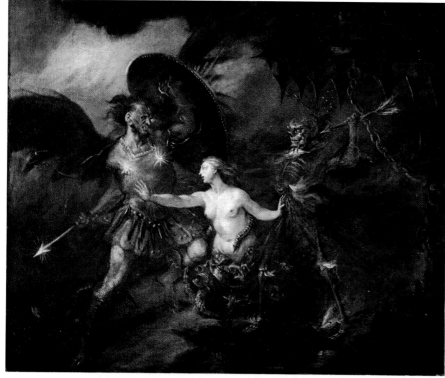

Satan, Sin and Death
circa 1735–40 (91)

41

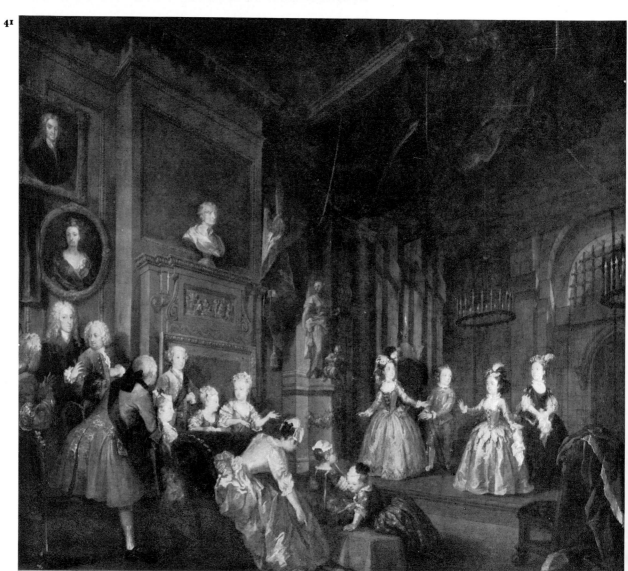

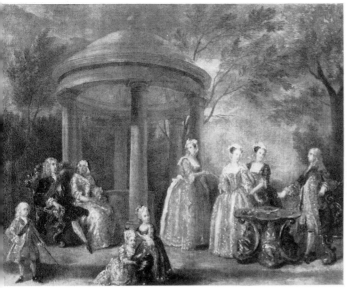 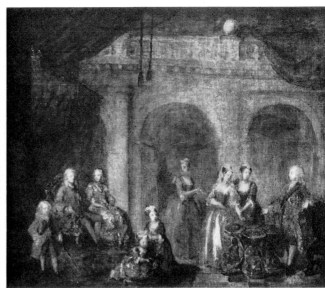

39 The Royal Family (I) 1732–3
Oil on canvas, $25\frac{1}{8} \times 30\frac{1}{8}$. *Her Majesty The Queen*

40 The Royal Family (II) 1732–3
Oil on canvas, $24\frac{3}{8} \times 29\frac{1}{8}$. *National Gallery of Ireland, Dublin*

George II seated with Queen Caroline; the Duke of Cumberland standing on left; Princesses Mary and Louisa playing with a spaniel; on right Frederick, Prince of Wales with Princesses Anne, Amelia and Caroline. In the first sketch, perhaps a modello submitted for approval, only the Duke of Cumberland is studied from life. The project ran into difficulties. The second and more summary version sets the group in an interior, no doubt in the hope of a more favourable decision; Hogarth seems to have had a sitting only from the Prince of Wales, who disliked his parents. In 1733, when Hogarth was prevented by his enemy Kent, now established in the royal favour, from painting the marriage of the Princess Royal, the portrait group was also stopped. Vertue recorded: 'these are sad Mortifications to an ingenious Man. But its effect of carricatures wch he has hertofore toucht Mr. Kent. and diverted the Town. which he is like to pay for, when he least thought of it. add to that there is some other causes relating to Sir James Thornhill...'

41 The Conquest of Mexico 1731–2
Oil on canvas, $51\frac{1}{2} \times 57\frac{3}{4}$. *Teresa, Viscountess Galway*

Child actors performing Dryden's 'Indian Emperor or The Conquest of Mexico', staged at St. James's Palace before the younger members of the Royal Family on 27 April 1732 on the suggestion of the Duke of Cumberland who is included in the group. The performances were usually held at the house of John Conduitt, Master to the Mint and producer of the play. The picture, showing Act IV, scene iv, was commissioned by Conduitt.

42 The Cholmondeley Family 1732
Oil on canvas, $28 \times 35\frac{3}{4}$. Signed and dated. *The Marquess of Cholmondeley*

George, Viscount Malpas (1702–1770), later 3rd Earl of Cholmondeley, his wife Mary, the daughter of Sir Robert Walpole and three sons, George, Robert and Frederick. The Viscountess had died in 1731; putti above her head indicate that her portrait is posthumous. Malpas had served on the Fleet Prison Committee and later commissioned Hogarth to paint the heads in a hunting scene by Wootton.

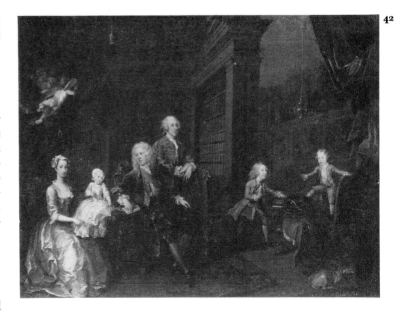

Art as Theatre

Hogarth traced the sources of his art to mimicry and the uncommon pleasure that 'shows of all sorts' gave him as a child. (His writings contain, among other things, an acute psychology of representation as he observed it in himself.) His earliest independent prints were concerned with theatrical fashion as an integral part of artistic taste and he was always aware that an artist who makes his own way is in the entertainment business. The production of *Henry IV Part II* in the autumn of 1727 from which he drew his first theatre picture offered exactly the concentrated natural expressiveness that he sought in painting and the appeal of *The Beggar's Opera* early in the next year was perhaps initially not very different. Its topicality and its success certainly made it more saleable; surrounded by its fashionable audience it made a profitable kind of conversation piece. His first version of the subject was descriptive, indeed pedestrian, but it introduced him to John Rich, the producer of the piece who became his friend and as he painted the later version that Rich and others called for he must have come to feel a kinship between it and his art. The ironic meaning of the play ran parallel to the naturally complex and sardonic reference of Hogarth's image from 'Hudibras' onwards. 'Subjects', he wrote, ' considered as writers do.' In *The Beggar's Opera* the significance was reinforced by events. In the age of Walpole any satire was understood to have a specific political force and the notorious affair between the leading lady and a Duke spanned the gap between the stage and the real world. *The Beggar's Opera* was in fact a model of the application of imagery to life which became characteristic of Hogarth's work. 'My picture', his notes continue, 'was my stage and men and women my actors, who were by means of certain actions and expressions to exhibit a dumb show.' The significance of satire in his time showed that the commentary, indeed the comedy of art might have a salutary value. 'Subjects of most consequence are those that most entertain and Improve the mind and are of public utility . . . If this be true, comedy in painting stands first as it is most capable of all these perfections.' Above 'The Beggar's Opera' in its first form the motto linked to the royal arms—Dulce Utile—emphasised the charms of moral usefulness. Hogarth sought for painting the indisputable force that is felt in the theatre. 'Ocular demonstration will convince sooner than ten thousand volumes and the decision is left to every unprejudiced Eye. Let figures be considered as Actors dressed for the sublime genteel comedy . . .' Above the elaborate final form of 'The Beggar's Opera' subject, which equates the play with its audience, roguery with aristocracy, art with life, another inscription is added: Veluti in Speculum Even as in a mirror.

The Beggar's Opera, from which Rich profited, was not typical of his own productions. He was the most famous Harlequin of his time (and had figured as such in the 'View of the British Stage'). Hogarth regarded Harlequin and the other 'distinctly marked characters' of the Italian comedy as pre-eminent examples of expressive action and described them at length in the *Analysis*. The design of his pictures from 'A Rake's Progress' onwards was closer to the diffuse eccentric patterns of the Commedia dell'Arte than the concentrated drama of the scene with Falstaff. It likely that it owed a good deal to the friendship that sprang from *The Beggar's Opera*.

45

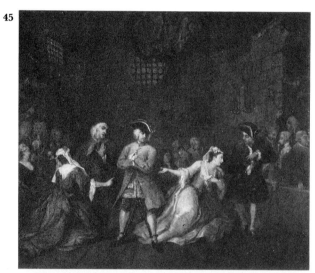

46

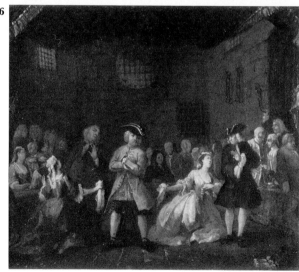

43 Falstaff Examining his Recruits *circa* 1728
Black and white chalk on blue paper, 15⅜ × 21¼.
Her Majesty The Queen, Royal Library, Windsor
Henry IV Part II was performed at Drury Lane with
Harper as Falstaff on 9 September 1727 and repeated
several times in the months that followed. Hogarth
shows Act III, Scene ii; his rendering seems to follow
an actual production. Apart from the engravings for
the editions of 1709, this drawing and the painting
developed from it were the first Shakespeare subjects
of the eighteenth century. They inaugurate Shakes-
pearian painting in British art. The theatre provided
Hogarth with an example of expressive intensity and
consistency quite foreign to the Flemish tradition of
grotesque genre from which this aspect of his style
derived.

44 The Beggar's Opera *circa* 1728
Black chalk with touches of white on blue paper,
splashed with oil colour, 14⅝ × 19⅜. *Her Majesty
The Queen, Royal Library, Windsor*

45 The Beggar's Opera II 1728
Oil on canvas, 20 × 20. Signed and dated.
Private collection

46 The Beggar's Opera IV *circa* 1728
Oil on canvas, 19 × 22½. *Private Collection*

47 The Beggar's Opera VI 1729–31
Oil on canvas, 22½ × 29⅞. *Tate Gallery*
(Reproduced in colour on p21)
John Gay's *Beggar's Opera* was produced by John
Rich in 1728. Hogarth's pictures show Act III,
Scene xi; to left and right Lucy Lockit and Polly
Peachum entreat their fathers, the gaoler and the
informer, to save the life of Macheath, the highway-
man, whom each supposes to be her husband.
Hogarth painted the subject at least six times. Versions
I (Mr W S Lewis), II (exhibited) and III (the Lord
Astor) are precise and vivid records of the dramatic
situation and its setting on the stage at Lincoln's Inn
Fields surrounded by the audience. IV (exhibited)
explores the possibility of a more mobile and evocative
rendering in a looser Venetian style, like that of Marco
Ricci's 'Opera Rehearsals'. The uneasy group of the
Peachums is studied afresh, with convincingly operatic
results. V (Mr and Mrs Paul Mellon) was com-
missioned by John Rich, who owned I, and is dated
1729. VI (exhibited) is a replica of it commissioned
by Sir Archibald Grant but still unfinished at the be-
ginning of 1731. The final form of the subject trans-
fers it to a larger stage in a grander theatre (such as
Rich was now planning to build out of his profits).
The satire on Italian opera becomes plain and there
is more than a hint of Italian painting in the group of
the Peachums which is redesigned on the lines of a
Noli Me Tangere. An irony is evident in a play show-
ing that rogues were no worse than their betters,
which was believed to satirise Walpole and the Court.
The prominent figure of a Satyr, which frames the
stage, as if raising the curtains on the show, has a
double meaning; it personifies both the satirical
reference and the desires of the Duke of Bolton in the
audience below it. The Duke was keeping Lavinia
Fenton, the Polly in the play and ultimately, twenty
years later, his Duchess.

48 Debates on Palmistry *circa* 1729
Oil on canvas, 24 × 29. *Private collection*
The title was invented after Hogarth's death when the
picture was illustrated in the *Biographical Anecdotes*.
Nichols later suggested with no more reason that it
showed 'Physicians and Surgeons in an Hospital, who
are debating the most commodious method of receiv-
ing a fee . . .' The intention was evidently to give a
party of gentlemen conceived on the lines of similar
portrait groups in 1729–30 (and set in a chamber with
ancestral armour and a charming housemaid) a narra-
tive content, now mysterious, with a subtlety at the
opposite extreme to the melodrama of 'Falstaff' and
'The Beggar's Opera'. The picture shows the begin-
nings both of Hogarth's comedy of manners and of the
mature breadth of his style.

49 An Auction of Pictures *circa* 1730
Oil on canvas, 19 × 29½. *Lieut-Col H M C Jones-
Mortimer*
Probably based on the saleroom of Christopher Cock,
Hogarth's neighbour in Covent Garden, who had
commissioned two pictures from him in November
1728.

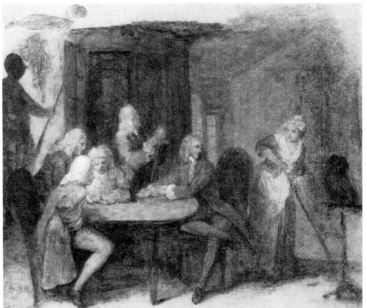

48

Modern Moral Subjects

Hogarth never separated the artistic problem from the economic one. Though the portrait conversation piece gave more scope than the common portrait, 'it . . . was still a kind of drudgery, as it could not be made like the former a kind of manufacture . . . That manner of painting was not sufficiently paid to provide what my family required. I therefore recommended those who came to me for them to other painters and turned my thoughts to a still newer way of proceeding, viz. painting and engraving modern moral subjects, a field unbroke up in any day or any age'. One kind of conversation piece could be turned profitably into 'a kind of manufacture', the 'Beggar's Opera' kind. It was the prototype of the new way of proceeding; its topicality was modern and it was moral in both senses—it dealt with both morality and *mores*.

Yet the motive for the development of the modern moral subject was only in part economic. The way he chose had to satisfy the man who had turned to painting with Thornhill's example running in his head, ' . . . desirous of appearing in the more eligible light of an History painter or engraver'. Any lower ambition, in the Flemish grotesque tradition for example, was by comparison ignominious. His self-respect (the great gift that made him so vulnerable) compelled him to believe and prove that the intellectual dignity of history painting was not the exclusive property of its unsaleable subject matter. It annoyed Hogarth that there was no one but himself to provide the rationale for his solution. 'Painters and writers never mention in the historical way any intermediate species of subjects between the sublime and the grotesque.' Later he welcomed if he did not dictate Fielding's description of him as a 'comic history-painter.'

Hogarth's other gift was the clarity with which he saw the situation of art in the new world. The painter had now no role except to market his one asset, his invention. If patrons would not pay enough for a painting, there was nothing for it but to sell it over and over again. His training placed the answer in his hands. It was no more than reasonable to replace the drudgery of copying with engraving and leave the duplication to the press. The new market that it reached was to his taste. 'Dealing with the public in general I found was the most likely do, provided I could strike the passions and by small sums from many by means of prints, which I could engrave from my Picture, I could secure my property to myself.' Other painters had profited from reproductive engraving. Rubens had organised the business hardly less efficiently than Hogarth himself. His originality was to marry the new market to a new aesthetic. The history of the modern moral subject is the evolution of his conception of what it is that strikes the passions.

The starting point, naturally enough, was erotic. The scandal that helped to sell 'The Beggar's Opera' and the appeal of titillating *sujets galants* from France both pointed in the same direction. While he was working on pictures like 'Before' and 'After' and the 'common harlot . . . just rising about noon out of her bed', who developed out of the drawing that he had made half-a-dozen years before, he must have thought of the old Italian picture stories. Vice and the fate that befalls it had provided the theme for series of popular prints since the sixteenth century. In Hogarth's world the idea of dramatic narrative had a very present, public force. The single, fetching painting of a whore developed by stages into a cycle of six— a drama transcending the taste for erotic entertainment and striking the passionate apprehension of moral fate and social vengence. The effect is described in Vertue's annals: 'The most remarkable Subject of painting that captivated the Minds of most People persons of all ranks & conditions from the greatest Quality to the meanest was the Story painted and designd by Mr Hogarth of the Harlot's Progress . . .' Hogarth's imagination remains intensely erotic, but the morality that concerns him is social. The comic histories evolved to deal with the element-like fantasy in a man, which determines his worldly destiny—his costume, his image and, most of all, the aspirations that are a kind of masquerade. Hogarth enabled his contemporaries to visualise the matter about which they were so infinitely curious, the nature of human self-determination, social and political, cultural and sexual as well. Later pictures are about the roles that men assume and about the failure of the role. In the invariable guise of entertainment the modern moral subjects confront us (like all great painting) with information about the grand and pathetic faculty of envisaging oneself.

Before I 1730–1
Oil on canvas, 14$\frac{7}{8}$ × 17$\frac{7}{8}$. *Fitzwilliam Museum, Cambridge*

After I 1730–1
Oil on canvas, 14$\frac{7}{8}$ × 17$\frac{7}{8}$. *Fitzwilliam Museum, Cambridge*

Before II 1730–1
Oil on canvas, 15$\frac{1}{4}$ × 13$\frac{1}{4}$. *Fine Arts Corporation*

After II 1730–1
Oil on canvas, 15$\frac{1}{4}$ × 13$\frac{1}{4}$. *Fine Arts Corporation*

Of all Hogarth's attempts to 'strike the passions' these pictures came closest to the *sujets galants* of the French engravers of the time. The landscape pair achieves the effect by realism; there is even a mild indecency, rare in Hogarth's work. The interior pair, probably painted second, contrive the same erotic reference by lavish symbolism in the accessories of each scene. The landscapes were commissioned by John Thomson, a member of the Commons Committee on prisons who was also associated with the Charitable Corporation for the Relief of the Industrious Poor. He never received the picture, as he fled to France with funds embezzled from the Corporation. The interiors were said to be painted for 'a certain vicious nobleman', apparently the Duke of Montagu. According to Nichols the male protagonist in the prints (1736) was Sir John Willes, later the judge in 'The Bench'.

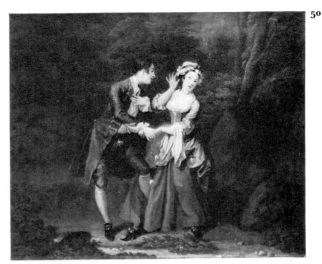
50

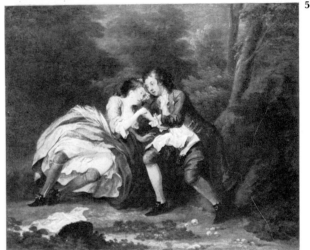
51

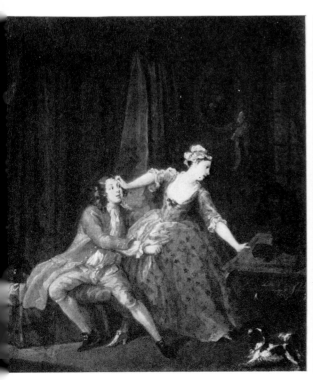

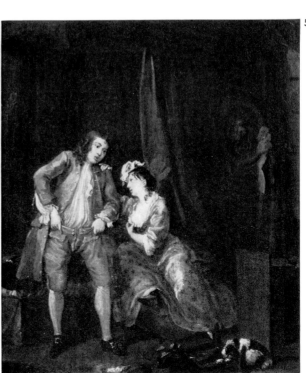
52, 53

54

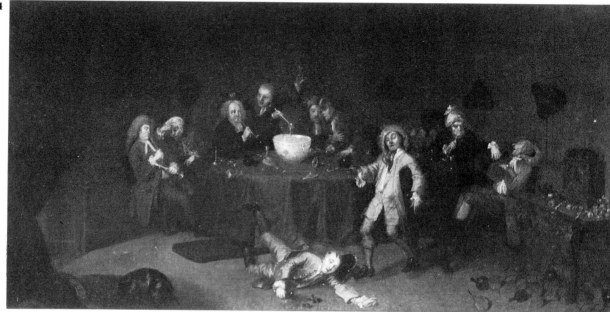

54 **A Midnight Modern Conversation** *circa* 1731
Oil on canvas, 30 × 64½. Signed. *From the
Collection of Mr and Mrs Paul Mellon, Upperville,
Virginia*

The scheme of a polite portrait conversation piece is
converted to a satirical purpose. As history painting
customarily shows the various reactions of partici-
pants to a theme, this design records the variety of
ways men take their drink. There is no sign of any
other form of debauchery. The caption of the print,
published in March 1733, includes the warning:
'Think not to find one meant resemblance there . . .'
but names have been suggested for several of the
figures. Other painted versions of the subject exist,
rather lower in quality. The print is less spacious and
more concentrated.

55 **Boys Peeping at Nature** 1731
Pencil, grey wash, touched with black ink, 4 × 5¼
Her Majesty The Queen, Royal Library, Windsor

56 **Boys Peeping at Nature** (Subscription Ticket)
(a) Second State, 1731
(b) Fourth State, 1751
Etching, 3½ × 4¾. *Trustees of the British Museum*

The original state, engraved as a subscription ticket for
the 'Harlot's Progress,' introduces a new order of sub-
ject in Hogarth's work. It indicates an erotic theme
from nature, yet links it to the classical tradition of
history painting. A satyr, restrained by a putto, seeks
to unveil the privacy of Nature (drawn from a
Rubens belonging to Thornhill and now at Glasgow)
—again with a double meaning; the exploration of
nature in the prints will express both satire and desire.
The quotations from Virgil (above) and Horace
(below) are similarly equivocal. The ticket, in fact,
is far from discouraging any prurient curiosity about
the prints to come.

The fourth state was used as a subscription ticket
for 'Moses brought to Pharaoh's Daughter' and 'Paul
before Felix'. It now introduced history painting alone,
and the motif of erotic exploration was replaced by a
schematic work of art.

56a, b

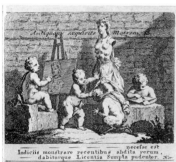
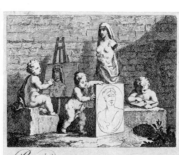

A Harlot's Progress Published April 1732
Etching and engraving. *London Borough of*
Hounslow, Hogarth's House.

7 **Plate One: Ensnared by a Procuress**
Fourth State, $11\frac{3}{16} \times 14\frac{3}{4}$.

8 **Plate Two: Quarrels with her Jew Protector**
Fourth State, $11\frac{7}{8} \times 14\frac{5}{8}$.

9 **Plate Three: Apprehended by a Magistrate**
Third State, $11\frac{3}{16} \times 14\frac{7}{8}$.

0 **Plate Four: Scene in Bridewell**
Third State, $11\frac{7}{8} \times 14\frac{15}{16}$.

1 **Plate Five: Expires while the Doctors are**
Disputing
Third State, $12 \times 14\frac{3}{4}$.

2 **Plate Six: The Funeral**
Third State, $11\frac{3}{16} \times 14\frac{7}{8}$.

7, 58, 59
0, 61, 62

Vertue described the origin of the paintings and the prints based on them, which were already famous, in his notebook for 1732: 'amongst other designs of his in painting he began a small picture of a common harlot, supposed to dwell in drewry lane. just riseing about noon out of bed. and at breakfast. a bunter waiting on her.—this whore's deshabillé careless and a pretty Countenance & art.—this thought pleased many. some advised him to make another. to it as a part. which he did. then other thoughts increased and multiplied by his fruitful invention. till he made six. different subjects which he painted so naturally. the thoughts & strikeing the expressions that it drew everybody to see them—which he proposed to Engrave in six plates to print at, one guinea each sett. he had daily Subscriptions came in, in fifty or in hundred pounds in a Week— there being no day but persons of fashion and Artists came to see these pictures. The story of them being related. how this Girl came to Town. how Mother Needham and Col. Charter first deluded her. how a Jew kept her how she livd in Drury lane. when she was sent to bridewell by Sr. John Gonson Justice and her salivation & death—' The story was entirely topical; all the chief names in 'A Harlot's Progress' appeared in the newspapers in 1729–30. Vertue had recorded in the previous autumn that 'Mr. Hogarth. haveing near 12 hundred— Subscribers.—For the Harlots progress, he had proposed to get them gravd. by the best gravers in Lond. but none that he employed pleasing him. he has set about them himself—to grave or finish the gravings'. The prints were issued in April 1732. The paintings remained in Hogarth's possession until bought by Alderman Beckford in February 1745 for 84 guineas. They were burned in a fire at Fonthill ten years later.

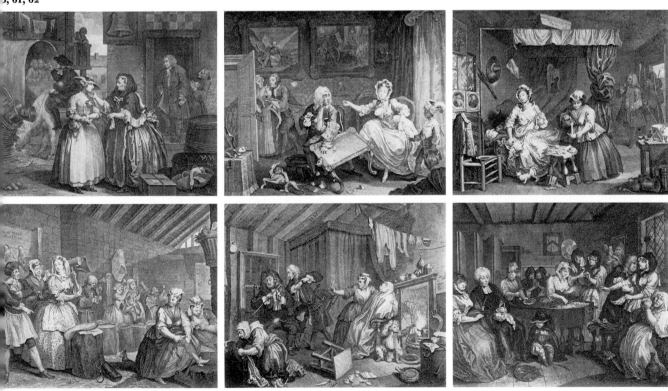

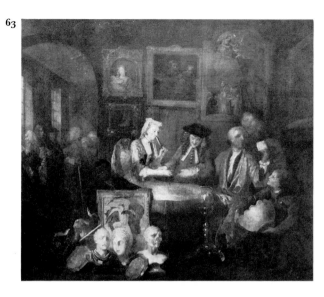

63

63 **The Marriage Contract:** Study for 'A Rake's
Progress' *circa* 1732
Oil on canvas, 24⅜ × 29½. *Visitors of the Ashmolean
Museum, Oxford*

A Rake's Progress *circa* 1733
Oil on canvas, 24½ × 29½ each. *Trustees of Sir Joh*
Soane's Museum

64 **The Young Heir taking Possession**

65 **Surrounded by Artists and Professors**

66 **The Tavern Scene**

67 **Arrested for Debt**

68 **Marries an Old Maid**

69 **Scene in a Gaming House**

70 **Prison Scene**

71 **Scene in a Madhouse**

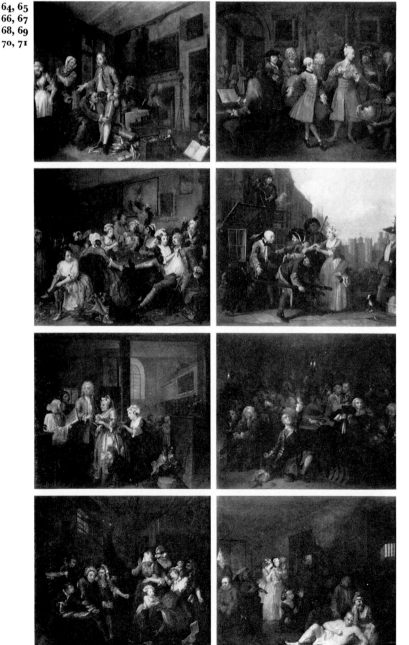

64, 65
66, 67
68, 69
70, 71

Hogarth seems originally to have conceived the stor
differently; the Rake was evidently intended to marr
an heiress in Scene II. At the moment of signing th
contract he is more interested in his messenger an
the 'superscription of a billet-doux'. The chief objec
of attack is, however, the collecting of antiquities an
old masters. In the second scene of the actual serie
the satire is directed rather at patronage. Only th
delicate glimpse (reminiscent of the painterly interior
by Marco Ricci) into a further room, where a peruke
maker, a tailor, a hatter, a milliner and a poet wit
an epistle are waiting their turn, remains from th
sketch.

Painted immediately after the publication of th
'Harlot'. The subscription for the prints, togethe
with one for 'Southwark Fair', was announced o
9 October 1733. The sequence was natural, and wa
common in popular picture stories. Hogarth's story i
unusual, however; the Rake falls victim to his ow
extravagance rather than to courtesans and whore
In style the series is resourceful. Scene III reflec
Dutch prototypes and Scene VI has the symmetr
and density of a classical bacchanal. But the characte
of the designs in general is strikingly new in Hogarth
work. Scene IV was probably suggested by a Con
media dell'Arte engraving after Gillot and the figure
in Scene II have the capricious, expressive move
ments of Commedia characters. This is amon
Hogarth's most original inventions and it is significar
that he made no attempt to paint it in reverse fc
easier transfer to engraving. It was therefore necessar
to reverse it on the plate to print in the original sens
and the first etching was made for Hogarth by Lou
Scotin. The other plates were probably begun b
Hogarth and finished by Scotin. In the last scene th
poses of the Rake and the lunatic behind him reca
C G Cibber's statues of melancholy and raving mac
ness from the gates of Bedlam. Publication was hel
up until 15 June 1735, the day on which the E
gravers' Act, which Hogarth had promoted, cam
into force. By then the 'Rake' had already bee
pirated.

72 **A Rake's Progress** Scene IV

Engraving, $12\frac{1}{2} \times 15\frac{1}{4}$.

(a) First State. Published 25 June, 1735.
 Trustees of the British Museum

(b) First State, retouched in ink. *Photograph of impression in the Lewis Walpole Library, Farmington, Connecticut*

(c) Second State. *Circa 1745. Photograph of impression in the Lewis Walpole Library, Farmington, Connecticut*

(d) Third State. *Circa 1763. Trustees of the British Museum*

The first state has the sunny atmosphere and the detached, descriptive mood of the painting. But an impression that Hogarth later retouched shows that a storm is gathering. In the second state (which Hogarth was selling in the later 1740s) the storm breaks. White's is struck by lightning. Figures of street urchins crowd on the darkened scene, imitating the fashionable gamblers under the sign of Black's. The narrative is confused by oppressive detail and ominous meaning. In the fourth state, dating from the last years, the cataclysm was redrawn again and made harshly schematic. It appears that the crisis was not only the Rake's. It reflected the changing mood of Hogarth himself. Other plates of the 'Rake' developed the same way. The subjects were loaded and overwritten almost to the point of self-cancellation.

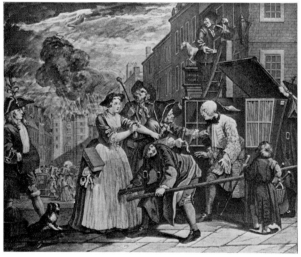

72a, b

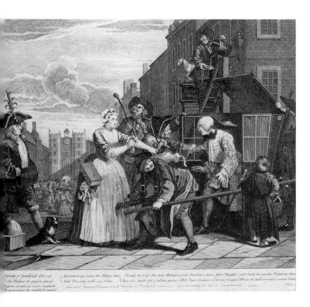

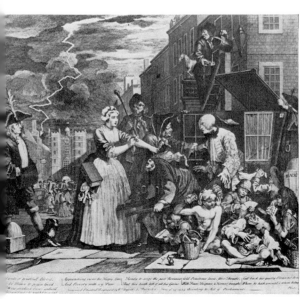

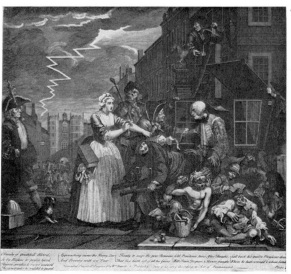
72c, d

33

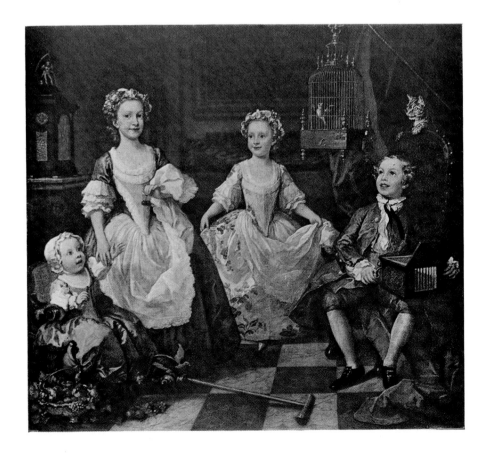

Benjamin Hoadly, Bishop of Winchester
circa 1743 (118)

The Graham Children
1742 (112)

Sarah Malcolm in Prison March 1732/33
Oil on canvas, $18\frac{1}{2} \times 14\frac{1}{2}$. *National Gallery of Scotland, Edinburgh*

[Ho]garth had accompanied Thornhill on his visit to [Ne]wgate in 1724 to paint his highly original picture of [th]e thief Jack Sheppard. Hogarth went to paint [Sa]rah Malcolm, a triple murderess aged 22, two days [be]fore her execution in Fleet Street opposite Mitre [Co]urt. No cautionary indications are included; the [ob]jectivity of the portrait was regarded as sufficiently [sal]utary. 'I see by this woman's features', Hogarth [re]marked to Thornhill who was with him, 'that she is [ca]pable of any wickedness.' The print of the picture [sel]ling at 6d, and giving the murderess an incongruous [tou]ch of elegance, was highly successful.

Southwark Fair 1733
Oil on canvas, $47\frac{1}{2} \times 59\frac{1}{2}$. Signed and dated.
Eunice (Lady) Oakes

[In] front of the old church of St George the players' [bo]oths advertise the siege of Troy, the fall of man and [th]e fate of Punch's victim in the Punch and Judy [sh]ow. To the left a troupe performing 'The Fall of [Ba]jazet' have fallen themselves and in the crowd a [Ro]man emperor is arrested by the bailiff. The in-[sta]bility of fortune and the precariousness of illusion [ar]e exemplified everywhere at the fair. Beyond, the [hu]man scene is set against a rare glimpse of landscape. [H]ogarth was spending the summer months in the [co]untrified surroundings of the Surrey side of the river. [T]he actress's flailing legs among the timbers of the [st]age on the right recall Bruegel's 'Fall of the Magi-[ci]an' (rather than the work by Coypel which is some-[ti]mes suggested.) This passage in the print of 'South-[w]ark Fair', which was engraved in Hogarth's most [fr]ee and vigorous manner, may have suggested the [si]milar detail in Plate 30 of Goya's 'Disasters of War'.

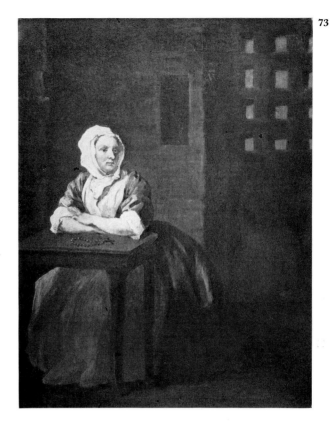

73

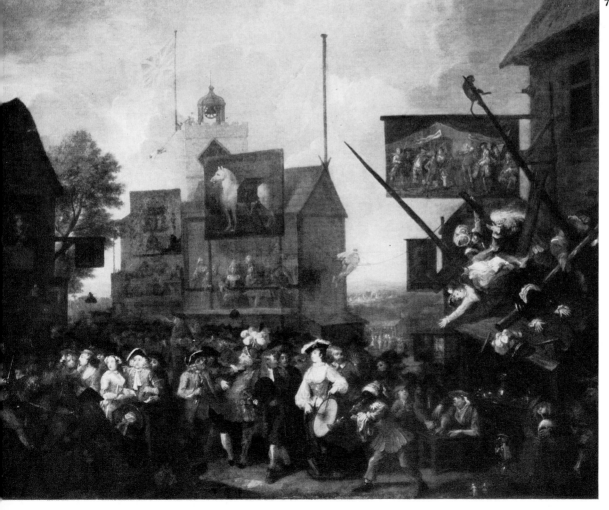

74

75 **The Distressed Poet** *circa* 1735
Oil on canvas, 25 × 30⅞. *City Museum and Art Gallery, Birmingham*

75, 76

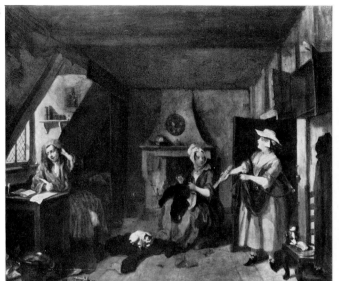

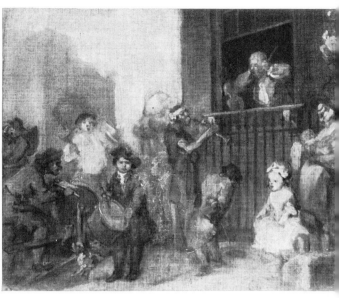

77

76 **The Enraged Musician** *circa* 1739
Oil sketch (monochrome), 14 15/16 × 18⅞. *Visitors of the Ashmolean Museum, Oxford*

'The Distressed Poet' works on a manuscript (which is identified in successive states of the print as 'Poverty a Poem' and 'Riches a Poem') instead of paying the milkmaid or keeping the dinner from the dog. The suggestion probably came from Pope's *Dunciad*; the print on the wall is a satire on him and the first state of the print was captioned with his description of Lewis Theobald, the King of Dunces:

> *Studious he sate with all his books around*
> *Sinking from thought to thought, a vast profound!*
> *Plung'd for his sense but found no bottom there;*
> *Then writ, and flounder'd on in mere despair.*

'The Enraged Musician' is said to have been suggested by an incident that befell a musician called Festi while waiting to give the future Lord Vernon a music lesson. The print based on it in 1741 was advertised as a companion piece to 'The Distressed Poet'. The set was to be completed by a third on painting. The theme of both is the failure of art to reconcile itself to the circumstances of real life.

The Four Times of Day

77 **Morning** *circa* 1736
Oil on canvas, 29 × 24. *The National Trust (Bearsted Collection, Upton House)*

78 **Noon** Published 4 May 1738
Engraving, First State, 17¾ × 15. *Trustees of the British Museum*

79 **Evening** Published 4 May 1738
Engraving by B Baron, Second State, 17⅞ × 14¾. *Trustees of the British Museum*

80 **Night** *circa* 1736
Oil on canvas, 29 × 24. *The National Trust (Bearsted Collection, Upton House)*

The first scene shows Covent Garden on a snowy morning, with an all-night tavern and adjoining brothel in front of St Paul's. The old maid walking to

78, 79

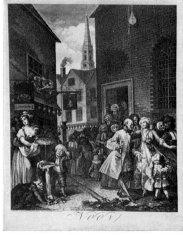

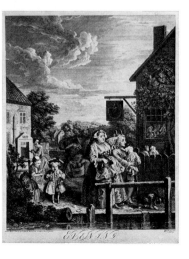

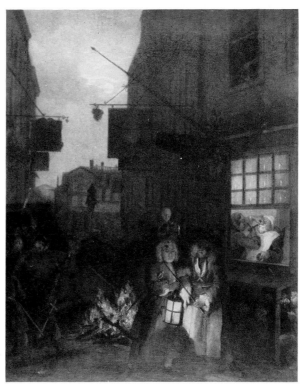

church is the only person who does not feel the cold. 'Noon' is set in Soho near St Giles in the Fields, a gutter divides the French community with its foreign observances from the healthy English appetites on the other side. In the third scene a family walks out to Sadler's Wells on a summer evening. In the second state of the print the woman's face is printed in a reddish ink to indicate a heat which is not due only to the weather; the hands of the husband, a dyer, are printed in a cold blue. The man is oppressed by his overwhelming wife, his cuckoldry and the burden of his child. The little boy is similarly the victim of the girl. 'Night' shows a street near Charing Cross on Restoration Day in May. The drunken Freemason is the strict but venal magistrate Sir Thomas de Veil, who had incurred the hatred of the mob by his enforcement of the Gin Act. Investigating a supposed sample of gin he had been the victim of a famous scatophilic joke; here he receives the contents of a chamber pot on his head. The 'Times of Day' display also the seasons of the year, the ages of man, heat and cold, lust and frigidity, indeed the elements and the humours as well, as they appear in the streets of London. Ways and conditions of life are the subject; for once the artist passes no judgment, unless it is an endorsement of natural pleasure in the prime of life and a distaste for restraint, excess and dogma. Nichols recorded that Hayman copied 'The Four Times of Day' for Vauxhall. 'Evening' and 'Night' were listed there in 1808 and in 1826 all four were in the collection of B Barret at Stockwell. One of these (or a further copy of one), which was among the Vauxhall decorations at Lowther Castle and lately on the market, is derived from the reversed engraving, making nonsense of the topography of the scene. It is thus unlikely the original paintings were intended for Vauxhall or that Hogarth was directly concerned with his use of his designs.

1 **A Chorus of Singers** Published 22 December 1732
Etching, First State, $6\frac{9}{16} \times 6\frac{1}{8}$. *Trustees of the British Museum*

2 **The Laughing Audience** Published December 1733
Etching, First State, $7 \times 6\frac{1}{4}$. *Trustees of the British Museum*

3 **Scholars at a Lecture** Published 20 January 1736/37
Etching and engraving, Second State, $8\frac{3}{16} \times 6\frac{5}{16}$. *London Borough of Hounslow, Hogarth's House*

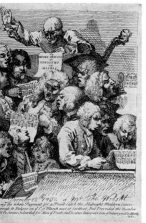
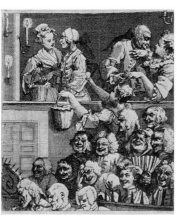
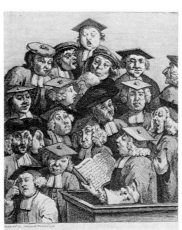
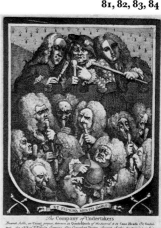

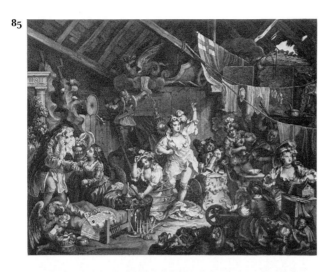

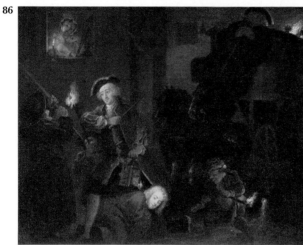

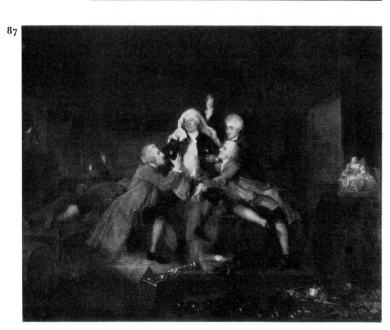

84 **The Company of Undertakers** Published
3 March 1736/37
Etching and engraving, Second State, $8\frac{5}{8} \times 7$.
Trustees of the British Museum

85 **Strolling Actresses in a Barn** Published May
1738
Etching and engraving, First State, $16\frac{3}{4} \times 21\frac{1}{4}$.
Trustees of the British Museum

Life behind the scenes is shown as a parody of a grand
baroque decoration. Its incongruities demonstrate
the falsity of the heroic convention, the hollowness of
illusion and the pitiful condition of the players. While
Hogarth was at work on the subject in May 1737
Walpole secured the passage of the Licensing Act, the
Act against Strolling Players tucked into the property
crown in the foreground, which silenced Fielding's
theatrical satires. The actresses are preparing for 'The
Devil to Pay in Heaven', their last performance before
the Act comes into force. They are the victims of
political repression. The painting which the print re
produces was burned at Littleton Park in 1874. This
was Horace Walpole's favourite among Hogarth's
works.

86 **A Night Encounter** *circa* 1738
Oil on Canvas, $11\frac{1}{4} \times 14\frac{1}{2}$. *From the Collection of
Mr and Mrs Paul Mellon, Upperville, Virginia*

87 **Charity in the Cellar** *circa* 1739
Oil on canvas, 39×49. *Private Collection*

The modern moral surveys of manners excited a de
mand for adaptations of such subjects to quite other
requirements. An eccentric heiress, Mary Edwards,
ordered a satire on current fashion in support of her
own highly independent views. Lord Boyne and his
friends in the Dilettanti Club, who had other tastes
in common besides encouraging the appreciation of
antiquity and awarding bursaries, had an interest in
dissipation quite untouched by the admonitory mes
sage that Hogarth's treatment of such scenes implied.
The implication was in fact sometimes more tenuous
than the later moralists supposed and in the picture
which Boyne commissioned in about 1739 it disap
peared entirely. 'Charity in the Cellar' used the
symbolic method of the moral subjects to celebrate
the antics of a night on which some of his friends
undertook to drink a hogshead of claret. The group
consists of Sir Thomas Hoby, centre, Lord James
Cavendish and a Mr De Grey, lower and upper left,
Colonel Mordaunt, right, and behind, Lord Galway.
The picture is dated 1739 on a copy (Huntingdon
Library and Art Gallery, San Marino) by R Livesay
whose information no doubt came from Mrs Hogarth.
In the 'Night Encounter', Lord Boyne, looking rather
younger than in the portrait he commissioned, is
allotted a heroic role in a fracas involving the watch
and a thieving link-boy outside an inn. The picture
was commissioned by Lord Boyne; the canvas ex
hibited, which is even more animated and vivid,
is evidently the artist's sketch. A manuscript note
is preserved which reads as follows: 'It represents
his lordship and Sir E. Walpole coming late from a
Tavern. Sir E. Walpole having fallen into a kennel
(gutter) is defended by Lord Boyne from the assault of
a watchman: at the same instant, but for the timely
check of the coachman, he was in more danger from
the horses of Lord Peterborough's coach.' The later
activities of the circle are reflected in the portrait of
'Sir Francis Dashwood at his Devotions'.

The Grand Style

Hogarth never gave up his ambition. At any moment something might provoke him—a successful rival, an insult to England, an over-praised old master or the shadow of a doubt cast on his powers—and set him off on another doomed bid to confer greatness on English art. He afterwards forgot that it was the threat of a fat commission going to Amiconi that spurred him to paint his first enormous history pictures without payment. Essentially his version of the story is right; it was the intellectual esteem of history painting that made it impossible to abandon the attempt. 'The puffing in books about the grand style of history painting put him upon trying how that might take, so without having a stroke of this grand business before immediately from family pictures in small he painted a great staircase at St Bartholomew's Hospital with two scripture stories, the 'Pool of Bethesda' and the 'Good Samaritan', with figures 7 foot high. This present to the charity he, by the pother made about the grand style, thought might serve as a specimen to show that, were there any inclination in England for Historical painting such a first essay would prove it more easily attainable than is imagined.'

The hope was not unreasonable. It was with just such a masterful and quixotic gesture that Tintoretto had beaten his rivals at San Rocco and Hogarth may have known the story, which has been famous ever since Ridolfi told it. Nevertheless it failed, and Hogarth, a student of the sociology of patronage, knew why. 'Religion, the great promoter of this style in other countries in this rejected it . . . To show how little it may be expected that history painting will ever be required in the way it has been on account of religion abroad there have been but two public demands within forty years, one for Lincoln's Inn hall, the other for St Mary's Church at Bristol, for both of which I was applied to and did them, and as well as I could recollected some of the ideas that I had picked up when I vainly imagined history painting might be brought into fashion.'

The search for an intellectual dignity for painting was pursued in the comic histories, but the disappointment was profound. Hogarth's darkening mood was largely due to it. He was under the necessity of proving single handed the legitimacy of his alternative to the great tradition. But he had lost 'the least hopes of bringing over those who have been brought up to the old religion of pictures and delight in antiquity and the marvellous and what they do not understand'. The past itself was in conspiracy to defeat his hopes for history painting in England. In fact there was more hope than he thought. One of his histories, the strangely original sketch of 'Satan, Sin and Death', had a profound influence on the imagery of Romantic art. Hogarth's conviction of defeat was, in fact, no defeat at all. It was embodied, with all its despair, in the new form of the Sublime—and in the victory of Romantic history painting forty years later.

88 **A Scene from the Tempest** *circa* 1730–5
Oil on canvas, $31\frac{1}{2} \times 40$. *Major the Rt Hon Lord St Oswald's Nostell Priory Collection*

The picture shows Act I, Scene ii. Shakespeare provided a source for history painting. The subject was later adapted, probably by Hayman, for one of the decorations in the Prince's Pavilion at Vauxhall.

89 **Study for the Pool of Bethesda** *circa* 1735
Oil on canvas, 25×30. *City of Manchester Art Galleries*

Study for one of the two pictures at St Bartholomew's Hospital, much elaborated in the finished work. The angel was used unaltered; like Ariel in 'The Tempest', it is reminiscent of a figure in Thornhill's Sabine room at Chatsworth.

90 **Nude Female Academy Figure** *circa* 1735–6
Black and white chalk on brown paper, $14\frac{5}{8} \times 11\frac{1}{4}$. *Her Majesty The Queen, Royal Library, Windsor*

Drawing for the figure centre right in 'The Pool of Bethesda'. The drawing is intermediate between the oil study exhibited and the finished picture.

91 **Satan, Sin and Death** *circa* 1735–40
Oil on canvas, $24\frac{3}{8} \times 29\frac{3}{8}$. *Tate Gallery*
(Reproduced in colour on p24)

The subject is from *Paradise Lost*, II, 648 ff. It may have been suggested by the elder Richardson's *Explanatory Notes on Paradise Lost* (1734) and the discussions at Slaughter's coffee house where Richardson read extracts from the book; he regarded the passage as epitomising the argument of the poem. The individual figures are derived from a rendering of the subject by Giacomo del Po, probably one of the works commissioned by English patrons. Hogarth assembled the figures differently in a less sophisticated design with a more primitive imaginative force. The enormous stride of Satan, for example, far beyond perspective calculation, powerfully evokes his movement; the fire, the fury and the sensual invention have no counterpart in the conventional painting of the time. The style seems closer to the abrupt emphasis of the 1730s than to any later manner. There is no other indication of the date and the connection (if there is one) with Buike's discussion of Milton's passage as a sublime theme, published in 1757, is therefore problematic. In 1767, when the picture was engraved, it was in the collection of David Garrick. Engraved by Charles Townley, S Ireland and by Rowlandson after R Livesay; its influence appears in a drawing by Fuseli (1776), sketches by Romney and works by Barry and Blake. In a more remarkable instance, the influence was transmitted by Gillray, who used the design in one of his adaptations of famous history pictures with Queen Charlotte as Sin, published on 9 June 1792. In this form, as the final watercolour study in the Louvre reveals, it was in David's mind when he planned 'The Intervention of the Sabine Women.'

92 **Female Nude** *circa* 1736–45
Black chalk on buff paper, $10\frac{1}{2} \times 16$. *Private Collection*

Probably connected with the lost picture of Danaë bought from Hogarth by the Duke of Ancaster.

93 **Paul Before Felix** 1748
Red chalk, $15\frac{3}{8} \times 20\frac{1}{8}$. *Pierpont Morgan Library, New York*

94 **Paul Before Felix Burlesqued** Published 1 May 1751
Etching, Fifth State, $9\frac{7}{8} \times 13\frac{1}{2}$. *London Borough of Hounslow, Hogarth's House*

95 **Paul Before Felix** Published 5 February 1752
Etching and engraving, Second State, $15\frac{1}{8} \times 20\frac{1}{16}$. *Trustees of the British Museum*

The painting of 'Paul Before Felix' was commissioned by Lincoln's Inn from a bequest of £200 by Lord Wyndham. The unusual subject from Acts 24 was appropriate both to the destination and to Hogarth's interest in the Raphael cartoons. 'Paul Before Felix Burlesqued', the subscription ticket for the engraving, reinforced Hogarth's classicist stand with a satire on the manner of Rembrandt.

Contemporaries were impressed by Hogarth's personal achievement in 'Paul before Felix'. Vertue noted: 'Some grand new designs of Mr Hogarth—painting much bigger than life, the story of St Paul at Ephesus—the greatness of his *Spirit* tho' a little man out to vye all other painters.' The next generation found the attempt to emulate Raphael misconceived. Reynolds in *The Idler* slyly applied to it the criterion of Hogarth's own theory, affecting regret that Raphael had not had the benefit of knowing about the Lines of Grace and Beauty: 'You would not then have seen an upright figure standing equally on both legs, and both hands stretched forward in the same direction, and his drapery, to all appearance, without the least art of disposition.'

96 **Nude Male Academy Figure Holding a Javelin** *circa* 1755
Black chalk, with white and red touches on blue paper, $21\frac{1}{2} \times 15\frac{3}{4}$. *Her Majesty The Queen, Royal Library, Windsor*

Similar in style to a study for the St Mary Redcliffe altarpiece; such active poses do not appear in the earlier history pictures.

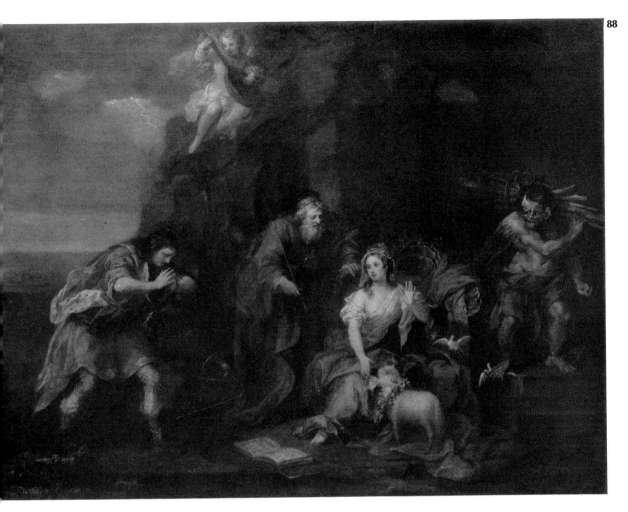

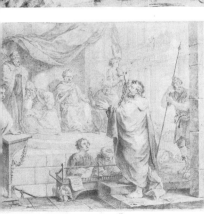

The Portrait Painter

Hogarth did not think highly of face painting. Those who did well at it were 'men of very middling natural parts'. Moreover, the business was always cornered by 'a very few monopolisers'. He turned to portraiture in a mood of disillusion with the chances for history and prompted by the success in London of J B Van Loo, just as the threat of Amiconi had set him to work on the pictures for St Bartholomew's; he could never bear to see a foreigner make a killing out of the English. The virtue and the limitation of the portrait style that Hogarth developed at the end of the 1730s were that he was in a mood to 'admire nature beyond pictures'. The treatment was direct to a fault; the arrangement was never particularly inventive. His way of modelling a head was the English way derived from Kneller (and thus originally from Rembrandt's studio), initially almost untouched by cosmopolitan suavity. The relief of a head was summarily moulded with a loaded brush, which gave a florid fullness to the shape. Highmore had painted not dissimilar portraits on the same pattern in the 1720s.

Yet his achievement was unparalleled and in a nation of great portraitists remains so. The drive that made Kneller a connoisseur of egotism was transformed in Hogarth into a solid appreciation of the social and sociable solidity of a man. He came to his sitters with an unaffected expectation that each would carry as much sensible, determined, combative and compassionate bulk as he did himself. He showed the aspect that a man presented to his fellows and the place that he occupied in his world with a completeness that invented what was virtually a new kind of image. The foretaste of the nineteenth century is sometimes strong; looking at 'George Arnold' it is quite difficult to believe that the only possible connection with the portrait by Ingres that Manet called the Buddha of the bourgeoisie is that Hogarth, with his intense perceptiveness of whatever is within the reach of common perception, was attending at the emergence of a new attitude, a new posture and a new persona in the man of substance, which remain as familiar to us as they were to Ingres.

The empirical freshness of Hogarth's approach to a head is the mark of a great painter. In the *Analysis* he took the head as the type of natural colour. He examined in precise and painterly detail the variegated dappling of distinct and brilliant tints —'colours cannot be too bright if properly disposed'— accounting for it by an extraordinary, romantic anatomy of the skin, 'a tender network, fill'd with different coloured juices', which was in fact an imaginary paradigm of painting. Hogarth's curiosity about beauty was accompanied by a profound disbelief in the ideal and an articulate sense of wonder at 'that infinite variety of human forms which always distinguishes the hand of nature from the limited and insufficient one of art'. A choice irony was reserved for the poor artist who 'is but able now and then to correct and give a better taste to some particular part . . . ten to one he grows vain upon it, and fancies himself a nature-mender'. Hogarth was a connoisseur of vanity but in portraiture he was at his best with sitters who gave little sign of it. The portraits show that the vein of loaded and salutary irony was only one part of the man. In another aspect he was both whole-hearted and most delicately responsive. The combination of qualities is quite incomparable with any other painter of his time.

97 **Gustavus Hamilton, 2nd Viscount Boyne**
1737–42
Oil on canvas, 19¾ × 14½. *Sidney F Sabin, Esq*
The portrait of the 2nd Viscount Boyne, who commissioned the three pictures recording the dissolute habits of his friends, exists in at least eight versions. Many of these show signs of Hogarth's workmanship. This version appears to be among the earliest.

98 **Lord Hervey and his Friends** *circa* 1737
Oil on canvas, 40 × 50. *The National Trust, Ickworth*
John Hervey, distinguished by the gold key of Vice Chamberlain to the Queen, was a capable, loose-moralled gentleman, eventually Lord Privy Seal, who changed sides twice. Pope attacked him as 'Lord Fanny' and he was Sporus in the 'Epistle to Arbuthnot'. He was a favourite with women, though the Duchess of Marlborough described him as having 'a painted face and not a tooth in his head'. His friends include Henry Fox, later Lord Holland, the Duke of Marlborough and the Rev Peter Louis Wilman, who falls from his chair in his eagerness to view a nearby village where he had been promised a living.

99 **Frederick, Prince of Wales** *circa* 1737
Oil on canvas, 30 × 20. *Her Majesty The Queen*

100 **Augusta, Princess of Wales** *circa* 1737
Oil on canvas, 30 × 20. *Her Majesty The Queen*
The art-loving Prince of Wales, round whom the opposition rallied, was married in 1736. The canvases, which appear to be modelli for pictures of considerable size, reflect the cosmopolitan decorative style in fashion in the following years. There is no evidence of a commission, sitting or payment to Hogarth and portraits of this kind could have served no purpose at court. Such pictures would have been appropriate decorations for a pavilion at Vauxhall which was dedicated to the Prince's use; this was eventually hung with Shakespearian subjects by Hayman.

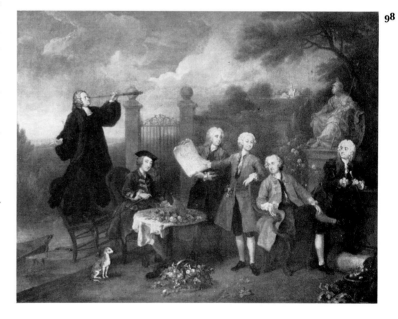

101 **Vulcan** 1735–40
Oil on canvas, 27½ × 36½. *Sabin Galleries*
Vulcan's owner, Thomas Wood was a friend of Hogarth who frequented the same club, possibly the Bedford Arms in Covent Garden. A note on the back of the picture records that the dog attracted Hogarth's attention by his nightly journeys to the club, carrying a lantern in his mouth to light his master home. A small full-length of Miss Wood painted early in the decade shows a similar landscape. Wood may have been the gentleman who, according to Horace Walpole, bid for the 'Rake' series saying, 'I *will* have my own progress.'

102 **A Lady in White** *circa* 1738
 Oil on canvas, 35⅝ × 27. *The National Trust*
 (*Rothschild Collection, Ascott*)

Formerly and erroneously thought to be a portrait of
Jane Hogarth, this may be the picture of Miss Wood-
ley, wife of the comedian Vaughan, which was
bought for the Rothschild Collection in 1869 and has
since been untraced.

103 **Dr. Benjamin Hoadly** *circa* 1738
 Oil on canvas, 22¾ × 18¼. *Fitzwilliam Museum,*
 Cambridge

Benjamin Hoadly (1706–1757), son of the Bishop, was
a well-known physician and Fellow of the Royal
Society. He was painted at least three times by Ho-
garth who was a friend of the family. He later wrote a
successful comedy, 'The Suspicious Husband' which
was performed by Garrick at Covent Garden in 1747,
and dedicated to George II who reciprocated by
sending Hoadly £100. His abiding service to Hogarth
was to help him in the writing of the *Analysis of*
Beauty. His brother John had provided the moralising
verses for 'A Rake's Progress'.

104 **The Strode Family** *circa* 1738
 Oil on canvas, 34¼ × 36. *Tate Gallery*

105 **Mrs Catherine Edwards** 1739
 Oil on canvas, 29 × 24. *Musée d'Art et D'Histoire,*
 Geneva

The unusually French air of this portrait may have
been prompted by the sitter's birth. She was the
daughter of a Frenchman, Louis Vaslet. The portrait
was painted at Shephall Bury in 1739, when she was
the wife of John Nodes; she became Mrs Edwards
after 1761.

106 **Miss Frances Arnold** *circa* 1740
 Oil on canvas, 35 × 27. *Fitzwilliam Museum,*
 Cambridge

107 **George Arnold** *circa* 1740
 Oil on canvas, 35⅝ × 27⅞. *Fitzwilliam Museum,*
 Cambridge

George Arnold (1683–1766), retired merchant and
collector of old masters (some of them genuine), was a
self-made man who built Ashby Lodge, Northants,
where Hogarth's portraits of him and his daughter
Frances are recorded to have been painted.

108 **James Quin** *circa* 1740
 Oil on canvas, 29½ × 24¼. *Tate Gallery*

The illegitimate son of a barrister and a woman who
claimed to be a widow but who was proved wrong,
James Quin (1693–1766) came to London from
Dublin in 1715, and until his retirement in 1751,
played nearly all the tragic leads in Shakespeare at
Covent Garden and Drury Lane, besides appearing in
lighter pieces, 'The Beggar's Opera' among them. He
killed two fellow actors in theatrical quarrels in as
many years. Quin suffered from comparison in turn
with Delane, Macklin and Garrick. In competition
with the last he made the famous remark, 'If this
young fellow be right, then we have been all wrong.'
A satire on the contest described his style: 'Mark one
who tragical struts up and down/And *rolls* the words as
Sisyphus his stone.' Smollet characterised him as one
whose 'wit was apt to degenerate into extreme
coarseness and manner into extreme arrogance'.
Dining with the Duchess of Marlborough and finding
that she ate no fat of venison, he exclaimed, 'I like to
dine with such fools.'

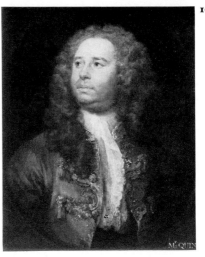

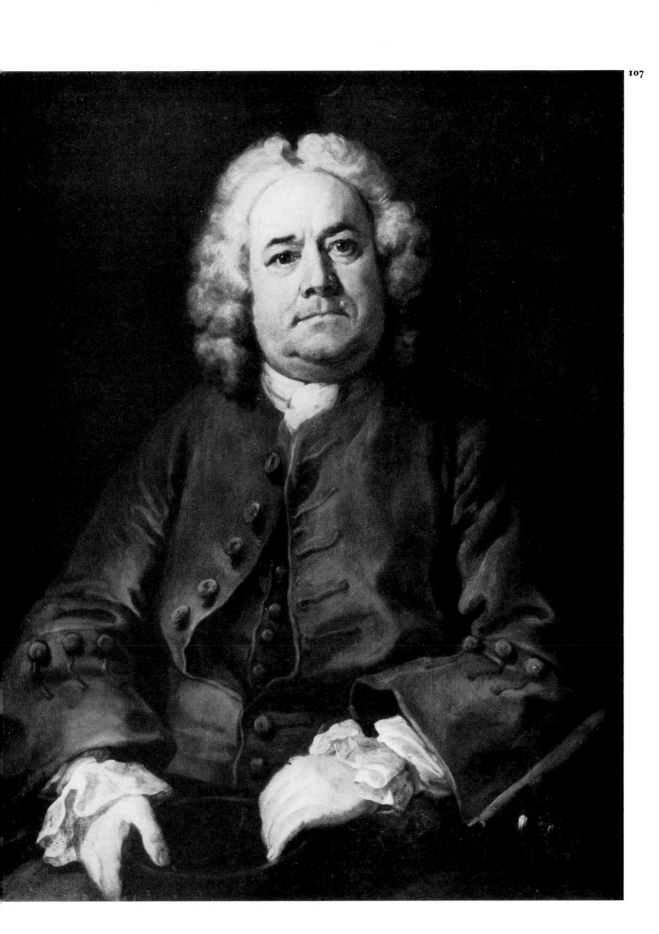

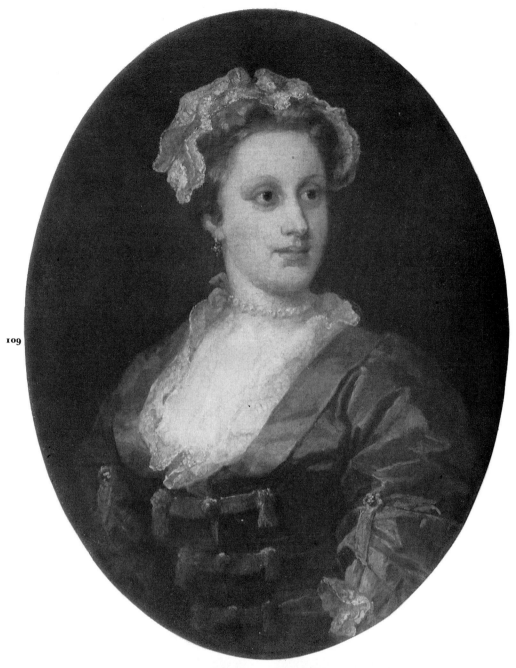

109

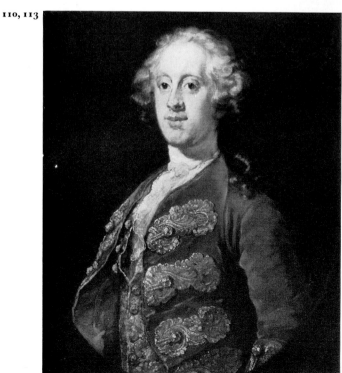

110, 113

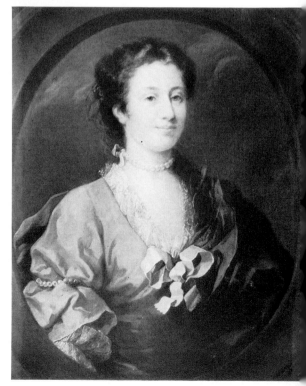

109 **Lavinia Fenton, Duchess of Bolton** *circa* 1740
Oil on canvas, 29 × 23. *Tate Gallery*
After a short period as an actress Lavinia Fenton (1708–1760) was given the part of Polly Peachum in 'The Beggar's Opera' and immediately became the favourite of the town, catching the eye of Charles Paulet, 3rd Duke of Bolton (1685–1754). She became his mistress, and in 1751, his wife. After her elevation she is said to have become 'so obnoxious to the lower orders about her place of residence, that they were with difficulty prevented from dragging her out of her coffin'. Horace Walpole noted that two years before her death she had 'after a life of merit, relapsed into her Pollyhood . . . ill at Tonbridge, she picked up an Irish surgeon,' who induced her to make him her heir.

110 **William Cavendish, 4th Duke of Devonshire** 1741
Oil on canvas, 29¼ × 24¼. Signed and dated.
Private Collection

11 **A Gentleman in Red** 1741
Oil on canvas, 29¼ × 24⅝. Signed and dated.
Governors of Dulwich College Picture Gallery

12 **The Graham Children** 1742
Oil on canvas, 63¾ × 71¼. Signed and dated.
Tate Gallery
(Reproduced in colour on p34)
The children of Daniel Graham, apothecary to Chelsea Hospital, provided Hogarth with another opportunity to introduce an overtone of allegory into portraiture. The scythe held by the figure of Cupid on the clock suggests the passing of this happy world where Orpheus and his magic lute still live, if only in the decoration on the toy organ, and cats kill no birds.

113 **A Lady in Yellow** *circa* 1740–5
Oil on canvas, 29¾ × 25¼. *Detroit Institute of Arts*

114 **Miss Mary Hogarth** *circa* 1745
Oil on canvas, oval, 18 × 16. *The Columbus Gallery of Fine Arts, Columbus, Ohio (Howald Fund)*

115 **Miss Ann Hogarth** *circa* 1740–5
Oil on canvas, oval, 18 × 16. *The Columbus Gallery of Fine Arts, Columbus, Ohio (Howald Fund)*
Mary, the artist's elder sister and Ann, his younger, kept a draper's shop near Long Lane for which Hogarth designed the Trade Card.

116 **Joseph Porter** *circa* 1740
Oil on canvas, 35¾ × 27⅞. *The Toledo Museum of Arts, Toledo, Ohio (Gift of Edward Drummond Libbey, 1926)*

117 **John Huggins** Before 1745
Oil on canvas, oval, 18 × 15¾. *Mrs Donald F Hyde, Somerville, New Jersey*
The Warden of the Fleet who sold the appointment to Bambridge. In 1758 Hogarth painted a companion portrait of his son; see catalogue number 201.

115

116

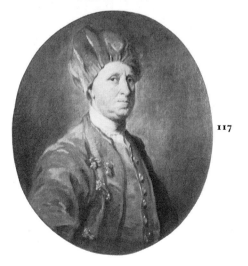

117

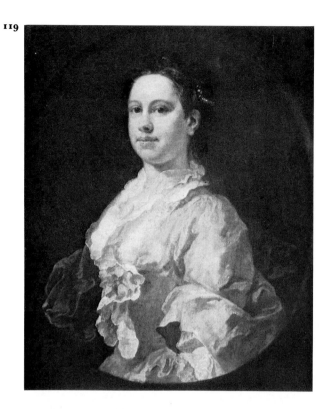

119

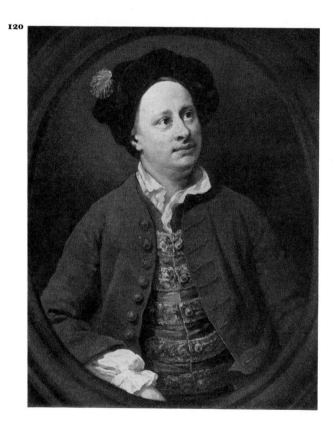

120

118 Benjamin Hoadly, Bishop of Winchester
circa 1743
Oil on canvas, 49½ × 39½. *Tate Gallery*
(Reproduced in colour on p34)

Bishop Hoadly (1676–1761), father of Benjamin the doctor, was noted for his good table, controversial theological writings, political affiliations and ability to acquire ecclesiastical preferment. He became a leader of the revolutionary 'low church' but later recanted and published an apology for his wayward life. His first wife Sarah was a portrait painter, and possibly the first of the family to know Hogarth. The portrait shows him in the robes of Chancellor of the Garter, and was probably based on an engraving of an earlier full-length of him, also by Hogarth.

119 Mrs Elizabeth Salter 1744
Oil on canvas, 30 × 25. Signed and dated. *Tate Gallery*

For many years believed to be a portrait of Ann Hogarth. It is now established that the sitter was Elizabeth Secker of Grantham who sat for her portrait shortly after her marriage to Rev. Samuel Salter, D.D., lecturer in theology at Charterhouse. It was one of the first pictures to be painted after Hogarth's return from Paris.

120 Richard James *circa* 1744
Oil on canvas, oval, 29½ × 24½. *Dr D M McDonald*

The James family—William, his brother Richard, sister Anne and wife Elizabeth—commissioned four matching portraits from Hogarth, all in feigned ovals and looking to the right. Richard was a London barrister who owned Ightham Court in Kent.

121 Thomas Herring, Archbishop of Canterbury 1744
Oil on canvas, 50 × 40. Signed and dated. *Private Collection*

After an active ecclesiastical life Herring (1693–1757) became a national hero when, in 1745, he mobilised loyalist forces in Yorkshire against Prince Charles Edward, the Pretender's son. Like Hoadly he dabbled in politics and had a lucrative succession of dioceses. The portrait, painted when he was Archbishop of York, is one of the earliest works where the influence of Quentin de la Tour, whose pastel portraits Hogarth admired, can be discerned; the successive phases of his style, robust and delicate in turn, can be observed superimposed in some parts of the picture. Despite Hogarth's assertion that 'the crown of my works will be the portrait of your Grace', Herring wrote that 'none of [his] friends could bear [the] picture'.

122 Captain Lord George Graham in his Cabin
circa 1745
Oil on canvas, 28 × 35. *National Maritime Museum, Greenwich*

A portrait group with an ingredient of comic history, probably set on board the Nottingham of which Graham, son of the Duke of Montrose, was captain. The picture may have been painted in honour of Graham's successful action off Ostend in June 1745 when he captured several French privateers. Hogarth's pug Trump, whose presence is a sign of the painter's friendship, is made to mock at the pomposity of more conventional and less convivial officers who would never be discovered without their wigs, keeping the roast duck waiting while they sang a catch to the accompaniment of pipe and tabor.

121

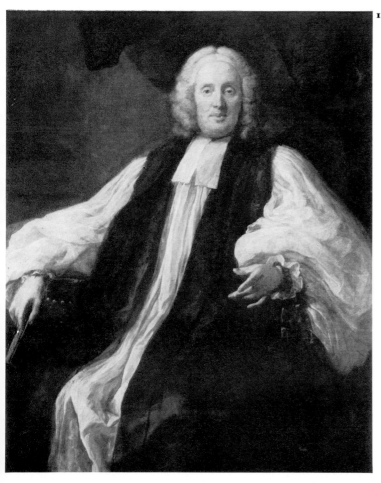

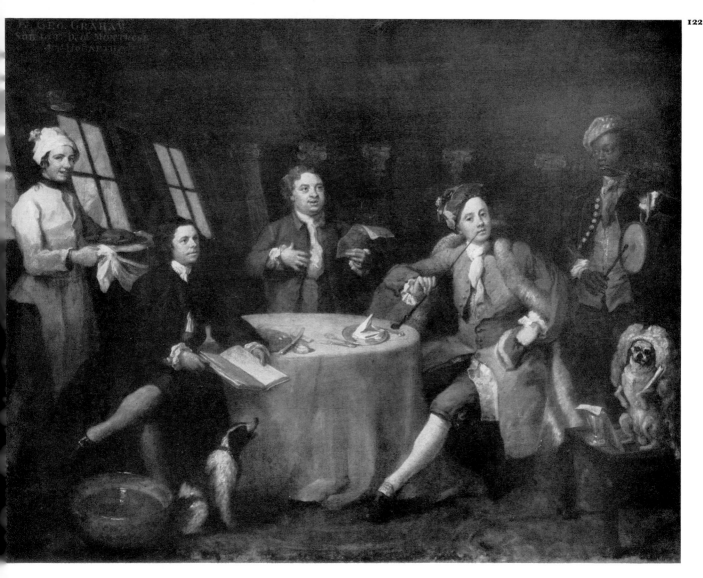

122

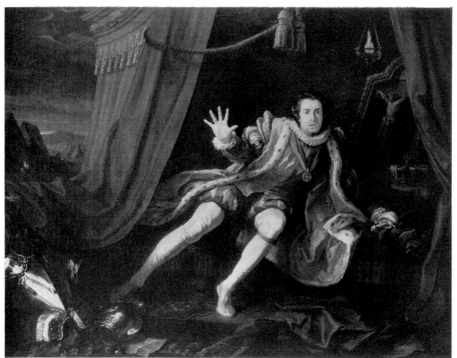

123 **David Garrick as Richard III** *circa* 1745
Oil on canvas, 75 × 98½. *Walker Art Gallery,
Liverpool*

Portraiture and the theatre as a basis for history
painting on the grand scale. The design follows Le
Brun's 'Tent of Darius'. Garrick's performance of
Richard III at Lincoln's Inn Fields in 1741 brought
him acclaim and opened up his career as the greatest
and possibly the most original actor of the eighteenth
century. The tent scene, Act V, Scene iii, which
was especially praised, inspired Hogarth to paint the
moment at which the King starts from his dream. The
price of £200 paid by Mr Duncombe, who commis-
sioned the picture, remained a matter of pride to the
painter.

124 **Mask and Palette** 1745
Etching, 4 × 4½. *Trustees of the British Museum*
Subscription ticket for the engraving of 'Garrick as
Richard III'. By an odd irony the mask and palette
design was used in 1766 to decorate the tablet in Bath
Abbey to Garrick's rival, James Quin.

125 **Sir Francis Dashwood at his Devotions**
1742–6
Oil on canvas, 48 × 35. *Private Collection*

The last of the commissions from the 2nd Viscount
Boyne, who died in 1746, to record the activities of his
circle. The likeness may derive from Knapton's
Dilettanti portrait of 1742, showing Dashwood in the
same role; he was nicknamed St Francis. The pecu-
liar commission offered the chance for ambivalent
sallies at several favourite targets—Catholic icono-
graphy, religious enthusiasm, the erotic masquerade
and the peculiarities of the great. The face in the halo
is said to be Lord Sandwich, whose second son Ho-
garth painted a few years later. Dashwood's rakish
play-acting developed at Medmenham in the 1750s
into a mock Society of Monks with a motto from
Rabelais, 'Fay ce que voudras'. There is no evidence
to connect Hogarth with this phase of the circle;
whatever his earlier view of the Dilettanti he would
have felt no sympathy after their support for the
foundation of an academy in 1749, and positive
enmity if he knew of their resolve in 1755 to dominate
it.

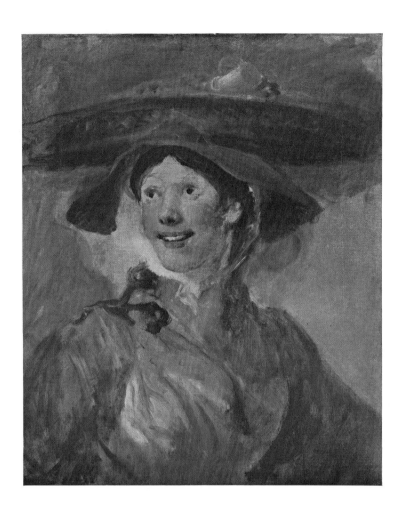

The Coarse, Bold Stroke

The high finish of fashionable cabinet pictures in the eighteenth century presented painters of spirit with a choice, which was to become a crucial issue of the Romantic period. There was a clear division between the natural boldness of the brush, which had been the subject of enlightened appreciation in Italy for 200 years, and the constricted execution of elegant decorations in the new French manner. As usual, Hogarth was acutely aware of the situation. He was influenced by at least one Neapolitan picture of the kind that cultivated animation of brushwork as a beauty in itself. He was certainly familiar with his father-in-law's numerous and admirable sketches. 'When a subject is trifling or Dull', he wrote with his customary admixture of irony, 'the execution must be excellent or the picture is nothing. If a subject is good', his note continues, 'providing such material parts are taken care of as may convey perfectly the sense, the

action and the passion may be more truly and distinctly conveyed by a coarse, bold stroke than the most delicate finishing.' The largest picture in the bold style of his sketches, 'The Fairies Dancing on the Green by Moonlight', was painted for Vauxhall. The attractions of the Gardens included the only public exhibition of paintings to be seen until the decoration of the Foundling Hospital under Hogarth's inspiration and the foundation of the Society of Artists. The sublimely poetic 'Fairies' hung there until his death and long after. It is good evidence that pictures in the sketch style were intended as a significant part of his achievement. Whoever doubts that historical conscience allows us to take pride in 'The Shrimp Girl' as a central European masterpiece of what is now regarded as pure painting can take courage. To judge by a remark reported of the faithful widow, the pride was shared by the Hogarths themselves. 51

26 **The Fairies Dancing on the Green by Moonlight** *circa* 1736
Oil on canvas. Two fragments 56 × 36 and 49½ × 59 from original of about 56 × 98. *Major A S C Browne*

Decoration for one of the supper boxes on the South side of the Grove at Vauxhall Gardens. Hogarth's friend Jonathan Tyers took a lease of the Gardens in 1728 and reopened them in 1732. Sources of information deriving from Hogarth's family and from Tyers agree that Hogarth gave the hint of the 'rational and elegant entertainment' at Vauxhall and thus 'assisted Tyers more essentially than by a few pieces he painted for the decorations'. The newly decorated Gardens opened in 1736; evocations of fairyland and the magic of moonlight were among the early delights here. The subject of 'The Fairies' was perhaps suggested by Purcell's *Fairy Queen*, the adaptation in which the early eighteenth century best knew *A Midsummer Night's Dream*. The ascription to Hogarth is confirmed by traces under the present picture of an earlier subject in his style of the 1720s; the work of Hayman, the other painter associated with Vauxhall, who painted the majority of the decorations, has no resemblance to 'The Fairies'.

27 **The Staymaker** *circa* 1737–45
Oil on canvas, 27¾ × 36. *Tate Gallery*

Engraved under this title in 1782. The theme and the purpose are unknown. Differences in the scale of the figures as well as in the character of design and style make a connection with 'The Happy Marriage' scheme unlikely. The group on the left, suggested by 'Le Tailleur pour Femmes' engraved after Cochin le Jeune in 1737, was a late addition to the sketch, which possibly dates from soon after. A lost Vauxhall decoration with the title of 'Difficult to Please', which would apply well to the various incidents here, may have been based on this design. In the *Analysis* Hogarth took a well-made stay as the prime example of the waving line which he regarded as 'the Line of Beauty'.

28 **Ill Effects of Masquerades** *circa* 1740–2
Oil on canvas, 11 $\frac{13}{16}$ × 14 $\frac{9}{16}$. *Visitors of the Ashmolean Museum, Oxford*

The title is due to Samuel Ireland, who gave a fanciful account of the subject. The design distantly foreshadows 'The Death of the Countess' in 'Marriage à la Mode', but it is more likely that the sketch was an earlier attempt to evolve a domestic history on the basis of a Lucretia or Non Dolet that Hogarth had seen.

29 **The Shrimp Girl** *circa* 1745
Oil on canvas, 25 × 20¾. *Trustees of the National Gallery, London*
(Reproduced in colour on p51)

In the possession of the artist and his widow until 1790. The canvas seems to have been reduced slightly to the present size in the course of painting. Mrs Hogarth used to tell visitors who looked at 'The Market Wench', 'They say he could not paint flesh. There's flesh and blood for you;—them!'

128

The Foundling Hospital

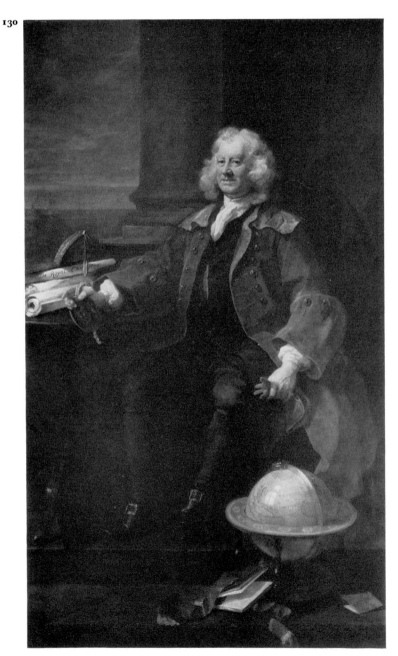

From the time of the horrific investigation at the Fleet, Hogarth's humane concern was clear throughout his work. The motto above his first mature pictures announced a commitment to the social usefulness of art which was strong as ever in the notes that he wrote at the end of his life. In his art the pity was outweighed by indignation at the common lack of it. Compassion required more practical expression. Hogarth shared the enlightened determination of his time that liberality should be incorporated in liberal institutions. A generation of painters profited from his free academy in St Martin's Lane; nothing affected him more sorely than the attempt in the 1750s to establish another on the authoritarian French model. The hospital was the humanitarian counterpart of the academy; as well as the immediate benefit, it fostered knowledge that the community needed. Many of the finest physicians were Hogarth's friends; *The Analysis of Beauty* itself was influenced by their thinking.

At St Bartholomew's where he was elected a governor in 1734, Hogarth was largely concerned with art, indeed with art-politics and his advancement; no one can have thought the less of him for that. Hogarth's connections with the hospitals, advising one painting for another, provided something that was needed. There was a hope that charity would promote the art that religion in England rejected. Not that he was backward with donations to St Bartholomew's, both in pictures that are near to masterpiece and in money for the building fund. But the hospital that engaged Hogarth most deeply dealt with a malady that was social and moral. Already Thomas Coram's friend, he was a governor of the Foundling Hospital from its foundation in 1739. His portrait of Coram the next year was a simultaneous and deliberate demonstration of the benevolent grandeur of the man and of the magnitude of the painter's power. In three years Coram was out; Hogarth never received a commission for another formal full-length portrait.

Hogarth's work for the Foundling Hospital was none the less a triumph. In the Court Room of the new building the decorations that Hogarth inspired linked history with landscape in an original and coherent iconographic scheme, established in each style to match the idea and foreshadowed in both the spirit of the age that was beginning. By comparison with this achievement any other decoration of the time looks tasteless or heartless.

130 **Captain Thomas Coram** 1740
Oil on canvas, 94 × 58. Signed and dated.
Thomas Coram Foundation for Children

The Coram portrait and the rivalries of which it was the outcome were among the climactic events of Hogarth's life. The French portrait painter J B Van Loo was monopolising the fashionable business. 'I exhorted the painters . . . to oppose him with spirit. But was answered, 'You talk! Why don't you do it yourself?' Provoked by this I set about this mighty portrait and found it no more difficult than I thought it. One day at the academy in St Martin's Lane I put this question: 'If anyone now was to paint a portrait as well as Vandyke, would it be recognised and the person enjoy the benefit?' They knew I had said I believed I could. The answer was made by Mr Ramsey and confirmed by the rest: 'Positively no.' The reason was given very frankly by Mr R: 'It is our opinion must be consulted and we will never allow it.' Upon which I resolved, if I did the thing I would affirm I done it . . . The portrait of Captain Coram in the Foundlings was given as a specimen, which still stands in competition with the efforts that have been made since by every painter that has emulated it . . . Yet the current ran against me. . . . I was forced to drop the going on . . . as the whole nest of Phizmongers were upon my back . . .'

131 **Theodore Jacobsen** 1742
Oil on canvas, 36 × 28. Signed and dated.
Allen Memorial Art Museum, Oberlin College, Ohio
Architect of the Foundling Hospital

132 **Moses Brought to Pharoah's Daughter** 1746
Oil on canvas, 70 × 84. *Thomas Coram Foundation for Children*

One of the four major pictures of cognate biblical subjects painted for the Court Room in 1746 and donated by the artists after 'the governors refused to apply any of the charitable contributions to this use', according to Rouquet, whose information certainly came from Hogarth. The others were 'Hagar and Ishmael' by Highmore, 'The Finding of Moses' by Hayman, respectively Dutch and French in their stylistic antecedents, and 'The Children brought to Christ' by James Wills, a remarkable anticipation of the sentimental classicism of narrative painting in the later eighteenth century. These alternate with landscape roundels of the hospitals of London by Wilson, Wale, Haytley and the 21-year-old Gainsborough. (As Hogarth was involved the scheme was, among other things, England's answer to Canaletto, who arrived in London in May 1746.) The chimney-piece by Rysbrack shows 'Charity Children Engaged in Navigation and Husbandry'.

131

132

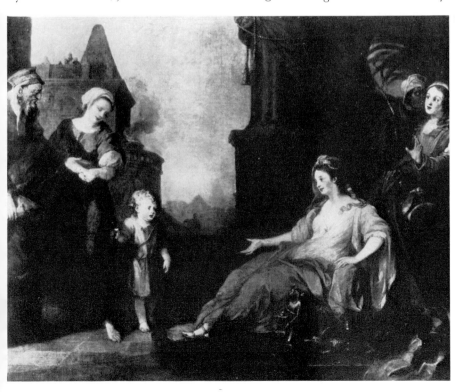

The Image of the Artist

Hogarth's refusal in his 20s to fit into the role of obedient tradesman set a pattern. At 35, in the convivial mood of the peregrination, he had a sharp awareness of the division between the Somebodies, the gentlemen-antiquaries and connoisseurs, and the gay Nobodies who enjoyed life and painting. On the threshold of a new society he perceived the place to which privilege and aesthetic knowingness had relegated the artist and rejected it with native pugnacity. He cultivated the combative pose, as if it were inseparable from the insight, and cherished the dog that was chosen to personify it. Love me, the portrait demands, love my pugnacity. Embrace my view of the greatness of England and the grandeur of satire. Puzzle over the Line of Beauty until you see the way 'to prevent the confusion and contradiction about the worth and goodness of pictures'.

The serpentine line, even though it had been anticipated by Lomazzo, was Hogarth's own weapon against academic befuddlement. He was a creature of the age that formulated the idea of aesthetic disinterest. It was due to him that the idea of artistic detachment carried with it from the first a built-in opposition. He lodged a furious objection, springing from a determination both that the meaning of art should have a natural human reference and equally that artists should not starve. It was Hogarth, more than anyone, who identified the right of the artist which was the basic creation of the two centuries before 1720, as a right to resist the tyranny of the instituted idea of art.

The economic foothold that an artist gains and the public figure that he cuts are real parts of his creation. Like the rest of what he makes, they bear the marks of his tribulation. Hogarth wore his tribulation, if not like a rose, like the scar on his forehead which he pushed his cap proudly back to show. He gave his society chance after chance to prove itself as grand and as generous as his ambitions. When it refused them, it no more than confirmed his expectations. The injustice-collector inside him was waiting. Involuntarily he prepared his own defeats. There was naïve honesty in the compulsion to advertise the old masters as his rivals and persecutors, rising in the air against him, poking their vicious corners through his pictures. Did he really expect to get good prices for his pictures at a sale announced by his fantasy of their destruction? The wind had changed and the confident post of defiance had frozen into something like paranoia. Hogarth took a sardonic pride in having grown 'so profane as to admire Nature beyond Pictures . . .' but it carried a fearful corollary: ' . . . for which I have suffered a kind of persecution'. Horace Walpole hoped 'that no one will ask me if he is not mad'.

The mood of mortification in which the story ends seems to divide Hogarth against himself. Nevertheless it gave a view of the truth; even the most bitter and obsessive of his portrayals of the dilemma that pride and talent faced in a certain social context contribute to his meaning. Throughout Hogarth's work the social struggle that he shows is intensified by the fury of his personal battle and darkened by the prospect of his defeat. Violence is his ultimate medium as well as his subject. The tribulations of art, which injure a faculty of the community, are themselves a part of social suffering. Hogarth's ultimate subjectivity and imbalance tell more of value about the pressures of society even than the moralists and sociologists have claimed.

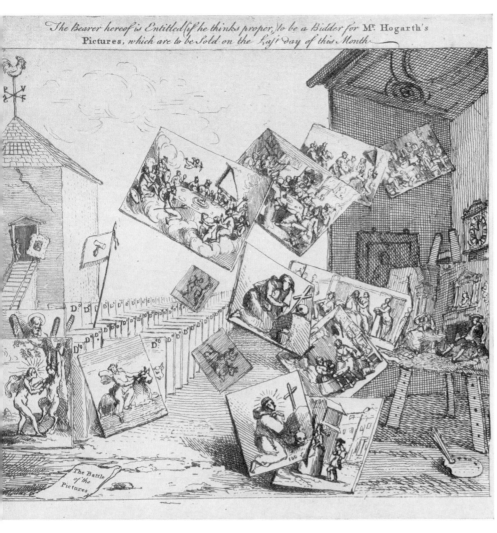

The Bearer hereof is Entitled (if he thinks proper,) to be a Bidder for Mr Hogarth's Pictures, which are to be Sold on the Last day of this Month

The Battle of the Pictures

33 An Account of what Seem'd most Remarkable in the Five Days Peregrination . . .

1732

Manuscript by Ebenezer Forrest with drawings by Hogarth and Samuel Scott, in original binding. Open at p15, **Mr. Nobody**.

Brown ink over pencil with watercolour, 11 × 15.

Trustees of the British Museum

Illustrated description of an impromptu tour of North Kent on which Hogarth and four of his friends decided when they met in the Bedford Arms, Covent Garden, on the evening of 26 May 1732. The party, which included the painter Samuel Scott, Hogarth's brother-in-law John Thornhill, Ebenezer Forrest, a lawyer and William Tothall, a cloth merchant, travelled by river to Gravesend and set out in the early morning on an itinerary that took them to Rochester and Stoke, then across the Isle of Grain and over the Medway to Sheerness and Queensborough. They reached Minster and returned to Sheerness for a rough journey home by boat. The account is supposed to have been written, illustrated and bound in two days. It is both a burlesque of pretentious antiquarian travels and a celebration of the vulgar pleasures which the companions shared. The antithesis is given a personal twist by Hogarth in the emblematic headpiece and tailpiece contrasting a consequential Mr Somebody with the common enjoyments of Mr Nobody.

134 The Battle of the Pictures Published February 1744/45

Etching, 7 × 7⅞. *Trustees of the British Museum*

Ticket of admission to bid at the auction of the original paintings of Hogarth's first three series, 'A Harlot's Progress', 'A Rake's Progress' and 'The Four Times of Day', together with 'Strolling Actresses in a Barn'. The peculiar system of sale, with bids recorded in writing in a book and a time limit fixed for each lot, was intended 'to prevent Confusion, or any indirect Practices frequently made use of at public Auctions'. Hogarth was dissatisfied with the prices realised, but Vertue, an unfriendly commentator, was impressed: '. . . by this means he could raise them to the most value & no barr of Critick's Judgement nor—cost of Auctioneers. and by this subtle means. he sold about 20 pictures of his own paintings for near 450 pounds in an hour'. The 19 pictures in fact fetched £427.7s.

On the left is Cock's auction room with copies of old paintings of 'St Andrew', 'The Flaying of Marsyas' and 'The Rape of Europa' stacked in rows. On the right is Hogarth's studio with the second scene of 'Marriage à la Mode' still on the easel. Floating in the air between them Hogarth's pictures are engaged in fantastic contest with the old masters. A 'St Francis' rips the frigid piety of 'Morning', a 'Repentant Magdalen' attacks the unrepentant 'Harlot' and 'Marriage à la Mode' receives the corner of 'The Aldobrandini Wedding'. Only Hogarth's pictures of revelry give better than they get. The 'Midnight Modern Conversation' and the Rake's 'Tavern Scene' damage a 'Triumph of Bacchus' and a 'Feast of the Gods'. Hogarth may have intended to suggest a heroic battle; the effect is of a cruel débâcle.

135 Portrait of the Painter and his Pug 1745
Oil on canvas, $35\frac{1}{2} \times 27\frac{1}{2}$. Signed and dated.
Tate Gallery
(Reproduced in colour on p73)

It appears that a projected half-length portrait, perhaps holding a palette in approximately the position of the palette here, was transformed by stages into the present still life with a canvas, conceived on the lines of the conventional engraved portrait frontispiece with emblematic framing. The engraving of the picture, dated 1749, was in fact used as a frontispiece for the bound volumes of Hogarth's prints over the title of 'Gulielmus Hogarth'. Hogarth's image of himself rests on volumes of Shakespeare, Swift and Milton, demonstrating not only the support that literature afforded him but the worthiness of a contemporary satirist (with whom he corresponded) to rank with the greatest. The dog, called Trump (one in Hogarth's succession of pugs; an earlier one 'answered to the Name of Pugg' and a successor was called Crab), was a late and defiant addition to the picture. Indeed he seems to stand for Hogarth's own defiance, particularly in the reversed design of the print, in which he catches the eye first and serves to introduce as well as guard his master. They were identified with one another in popular lampoons:

> *'Oh fie! to a Dog would you Hogarth compare?—*
> *Not so—I say only they're alike as it were . . .'*

The only part of the picture which is not reversed is the scar on the right of Hogarth's forehead. Moved to the correct side in the mirror image of the painting, it is moved again to keep it there in the reversed engraving; John Ireland recounted that Hogarth proudly pushed back his hat to show it. In the print Hogarth added a graver at Trump's feet. To the left is the painter's palette, and on it the detail that provoked most comment. Hogarth later described its reception (apparently confusing the dates): 'In the year 1745 [I] published a Frontispiece to my engraved works, in which I drew a serpentine line lying on a painter's pallet, with these words under it, "THE LINE OF BEAUTY". The bait soon took; and no Egyptian Hieroglyphic ever amused more than it did for a time. Painters and Sculptors came to me, to know the meaning of it, being as much puzzled with it as other people, till it came to have some explanation.' The talk reached Vertue's ears: 'Hogarth (in opposition to Hussey. scheem of Triangles.) much comments on the inimitable curve or beauty of the S undulating motion line, admired and inimitable in the antient great sculptors & painters.' In the painting the inscription 'The line of Beauty' originally continued '*and* Grace'; the words are painted out but legible. In fact this is clearly the three-dimensional serpentine line which was later identified in *The Analysis of Beauty* as the Line of Grace, as opposed to the two-dimensional waving Line of Beauty; the conceptions were evidently clarified in the intervening years. The work has all the marks of a manifesto-picture, both personal and aesthetic.

136 The Roast Beef of Old England, &c 1748
Oil on canvas, $31 \times 37\frac{1}{4}$. *Tate Gallery*
(Reproduced in colour on p73)

Hogarth was among a group of artists from the Foundling circle who visited France in the summer of 1748 following the armistice. On the way back from Paris with Hayman, Hogarth was sketching the fortified English Gate at Calais when the incident which confirmed his xenophobia occurred. He described his impressions in notes intended to accompany the print, which was published under thi title in the following spring: 'The first time anyone goes from hence to France by way of Calais he canno avoid being struck with the Extreem different fac things appear with at so little distance from Dover—a farcical pomp of war, parade of religion and Bustle with very little business—in short poverty, slavery and Insolence, with an affectation of politeness give yo even here the first specimen of the whole country. No are the figures less opposed to Dover than the two shores. Fish women have faces of leather and soldier ragged and lean. I was seized by one of them and carried to the Governor as a spy as I was saunterin about and observing them and the gate . . . As I con cealed none of the memorandum I had privately take and they being found to be only those of a painter fo his own use, it was judged necessary only to confine m to my lodging till the wind changed for our comin away to England where I no sooner arrived but se about the Picture wherein I introduced a poor high lander fled thither on account of the Rebellion th year before brozing on scanty French fare in sight of Sirloin of beef, a present from England . . . my ow figure in the corner with the soldier's hand upon m shoulder is said to be tolerably like.' Wilkie was ar rested for sketching the same gate in 1816.

137 Hogarth Painting the Comic Muse circa 175
Oil on canvas, $16 \times 15\frac{1}{2}$. *National Portrait Gallery*
(Reproduced in colour on p11)

The figure that the painter has drawn on his canva has the mask, ivy-wreath and sandals of Thalia, th Muse of comedy and idyllic poetry. Thalia, wh rejoices in wanton discourse, is not normally seen wit a book. This attribute is borrowed from Polyhymni the Muse of rhetoric, who has a book inscribed *Suader* In the print of the picture this Muse's book is seen t be marked *Comedy*. It indicates not only the branch o Thalia's activities that are concerned but the fact tha comedy has a persuasive function in Hogarth's art.

In its present form the picture is bare of all bu the essentials, the painter, his palette, his canvas an his ideal of comic art. The engraving, perhaps record ing a slightly earlier stage, shows him a little mor comfortably provided. He has his aesthetic theory i the shape of the *Analysis* and a pot of oil beside him his head is warmly covered. At an earlier stage stil revealed by radiographs, he had a model, a clothe man posing on a throne, and—most indicative—h had his obsessive grudge; in the foreground one of hi pugs relieved himself against a few old masters.

Studio pictures of an artist painting a muse ar rare in England (the triple portrait by J F Rigaud, NP is no doubt dependent on Hogarth) but the subje appears in Holland and examples by Metsu, Vermee and Rachel Ruysch are well known. A complex an crowded form of it drawn (in 1577) and etched b Marcus Gheeraerts the Elder, showing an artist di tracted from the muse Urania and the chance of im mortality by his wife and family, is of interest as i was possibly known to Hogarth and the source of change in the Rake's position in Scene viii fro Cibber's sculptured form used in the painting to th distracted pose in the engraving. In this context th austere concentration of this picture in its final for has special meaning. It illustrates, perhaps deliberat ly, the basis of Hogarth's bid for immortality. M Hogarth, who was childless, never distracted he husband and according to Nichols there was a com panion portrait of her.

138 Time Smoking a Picture Published March
1761

Etching and mezzotint, Second State, $8 \times 6\frac{11}{16}$.
London Borough of Hounslow, Hogarth's House

Hogarth wrote forcefully and justly against the sup-
position that age improved pictures. The fraudulent
practices of the picture trade and the credulity of con-
noisseurs were the continual objects of his scorn. Final-
ly the separate targets were combined into a compound
image of aesthetic vice. The print is an ironic pendant
to 'Hogarth Painting the Comic Muse' and indeed
almost the mirror image of it. The simple honesty of
the living painter is opposed to the lying myth of
venerable antiquity; against the salutary cleanliness of
comic art Hogarth sets the quackery of darkening old
masters, as if Time were a shady dealer on the make.

The unfolding of Hogarth's image of the artist's
role and fate ended in the year of his death with the
last two works in this catalogue.

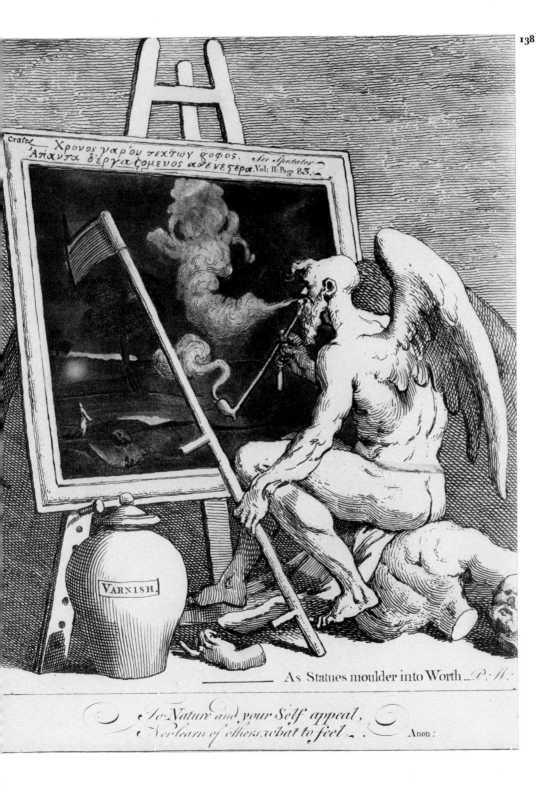

The Comic History-Painter

In the 1730s the development of modern moralities in paint could be empirical, taking advantage of every possibility that offered. Success and opposition alike, the emergence of a common basis for the new genre in both literature and painting and, most of all, Hogarth's instinctive need (as his forays in one direction and another were, as he considered, beaten back) for a defensible base for his attack all combined after 1740 to turn his thought towards the intellectual foundation of the order of image that he had made his own. Hogarth particularly resented one criticism: '. . . all were taught to run down my women as harlots and my men as caricatures'. It drove him, as he remembered, away from portraiture in the early 1740s, but it was equally damaging to his developing purpose in the moral subjects. In order to convey the meaning, the human image required its full weight.

It was Fielding who perceived the critical distinction, and it more than repaid the debt for the starting-point that Hogarth had provided 14 years before. Fielding defined the distinction at the beginning of another beginning in his preface to *Joseph Andrews* in 1742. '. . . Let us examine the Works of a Comic History-Painter, with those Performances which Italians call *Caricatura*; where we shall find the true Excellence of the former, to consist in the exactest Copy of Nature; insomuch that a judicious Eye instantly rejects anything outré, any liberty which the painter hath taken with the Features of that *Alma Mater*.—Whereas in the Caricatura we allow all Licence. Its aim is to exhibit Monsters, not Men; and all Distortions and Exaggerations whatever are within its proper Province.'

'Now what *Caricatura* is in Painting, Burlesque is in Writing; and in the same manner the comic Writer and Painter co-relate to each other. And here I shall observe, that, as in the former the Painter seems to have the Advantage, so it is in the latter infinitely on the Side of the Writer: for the Monstrous is much easier to paint than describe, and the Ridiculous to describe than paint. And though, perhaps, this latter Species doth not, in either Science, so strongly affect and agitate the Muscles as the other, yet it will be owned, I believe, that a more rational and useful Pleasure arises from it'.

'He who would call the Ingenious *Hogarth* a Burlesque Painter, would in my Opinion do him very little Honour; for sure it is much easier, much less the Subject of Admiration, to paint a Man with a Nose, or any other Feature of a preposterous Size, or to expose him in some absurd or monstrous Attitude, than to express the Affections of Men on Canvas. It has been thought a vast Commendation of a Painter, to say that his Figures *seem to breathe*; but surely, it is a much greater and nobler Applause, *that they appear to think*.' The idea was basic to Hogarth's subsequent development. The subscription ticket to 'Marriage à la Mode' referred his public to Fielding's preface for an explanation of the distinction and implicitly for a defence of the course that he proposed to follow.

The conception of modern moral subjects as a kind of history picture, which had been implicit before, was henceforward in the forefront of his mind. In 'Marriage à la Mode' the use of tradition was by no means ironic. The echoes in design, the complex fabric of symbolism and illustration, the constant reference to and from the ubiquitous accompaniment of art and taste and the magnificent elegance of figurative style enforce the message. The intention was to give comedy the indisputable dignity of history. As a painter Hogarth stood or fell by the attempt and the virtual failure of the sale seemed to give him his answer. Vertue reported that 'this so mortified his high spirits & ambition that threw him into a rage cursd and damned the publick. and swore that they had all combind together to oppose him . . . by this his haughty carriage or contempt of other artists may now be his mortification—and that day following in a pet. he took down the Golden head that staid over his door'.

Hogarth thought that he had finished with painting. On the score of rationality and usefulness there was no apparent need for it. The published engravings were not only a livelihood; 'dealing with the public in general' gave him access to a valid, indeed clinching court of appeal against the tyranny of cultivated taste. The social utility of the great series of independent engravings conceived towards the end of the decade was sincere and undoubted. It was the powerful motive that kept Hogarth's art developing, when the prospects for painting were a matter for despair. Yet this desperate retreat to the graphic and popular basis of his art was in fact no retreat at all. The *Analysis*, the conclusion of the compulsion to formulate an intellectual basis not only for his art but for all art contributed something to his culminating paintings, a new order of rhythmic structure that they could hardly have gained in any other way. The abandonment of 'The Happy Marriage' was not due only to the unaccustomed standpoint; there was no apparent reason why Hogarth should not have painted histories as lyrical and lovely as 'The Shrimp Girl', except that bereft of the descriptive animus, they would have remained sketches, like 'The Dance'. The greatness of 'An Election' is that the painterly substance at last gains its appropriate, wiry definition and with it its full humanity, the full power of a consistent style to make visible the consistency of society. To value 'An Election' truly we must see it not in the diminutive context of English painting in the 60s, but as a peak, perhaps the summit, of Rococo art in Europe, giving a unique view not only backward over the Baroque tradition but forward to possibilities that opened for painting in the Romantic age.

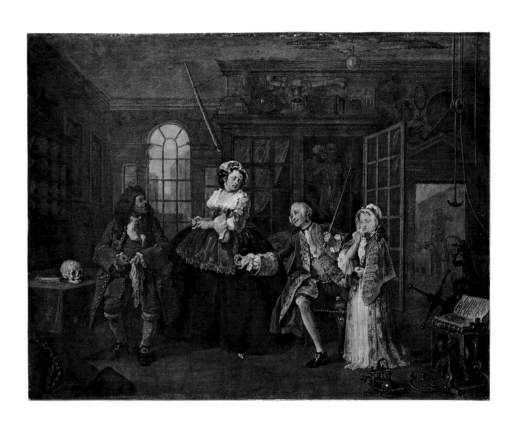

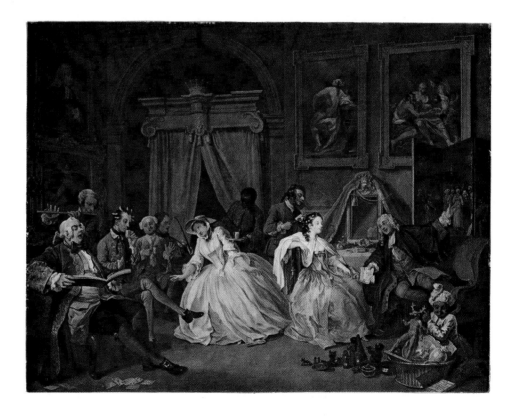

Marriage à la Mode III: The Visit to the Quack Doctor
circa 1743 (141)

Marriage à la Mode IV: The Countess's Morning Levée
circa 1743 (142)

Marriage à la Mode *circa* 1743

Oil on canvas, 27 × 35 each. *Trustees of the National Gallery, London*

The first of Hogarth's series to deal with high life, th[e] main object of the attack being the property marriag[es] that were common. Richardson had developed [a] similar theme in *Pamela* and *Clarissa*. High life as [a] subject appeared in the picture commissioned by Ma[ry] Edwards, 'Taste à la Mode', satirising the sartori[al] constraints dictated by fashion. Here an innoce[nt] couple are forced into the equally unnatural mould [of] an arranged marriage.

In April 1743 Hogarth announced his intenti[on] of publishing prints of the series, specially 'engrav'd [by] the best Masters in Paris', although 'the Heads for t[he] better Preservation of the Characters and Expressio[ns] (were) to be done by the Author'. By the beginning [of] May he had left for Paris to secure the engraver[s;] after some difficulty he procured G Scotin (who e[n-] graved Plates 1 and 6), Bernard Baron (Plates 2 an[d] 3), S F Ravenet (Plates 4 and 5) and further advertis[ed] the French character of the prints. Hogarth may we[ll] have reworked the paintings on his return; they di[s-] play a lightness and delicacy that is suitable f[or] engraving in the French manner.

The prints were published in June 1745. Hogart[h's] difficulty in selling the paintings at the price the[y] merited influenced his concentration on engraving [in] the following years. They were finally sold in 1750/[5] to Mr Lane for 120 guineas in one of his ill-fate[d] attempts to improve on the usual form of auctio[n.] Writers took a good deal from 'Marriage à la Mod[e',] notably Shebbeare in *The Marriage Act* of 175[4.] Colman and Garrick acknowledged or claimed i[ts] inspiration in the Prologue to *The Clandestine Marria[ge]* in 1766, which had in its turn a wide and internation[al] influence, notably on *Il Matrimonio Segreto* by Cim[a-] rosa. Other operas returned to the source; 'Th[e] Countess's Levée' suggested the first act of *D[er] Rosenkavalier*.

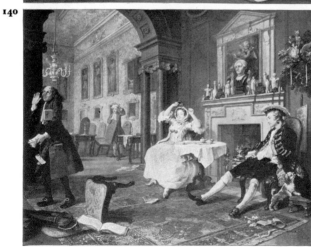

139

140

139 Marriage à la Mode I
The Marriage Contract

A marriage of economic convenience is being arrange[d] at the house of the groom's father, Lord Squande[r.] The dowry, a good if costly investment for the miserl[y] alderman who scrutinises the settlement, will repleni[sh] the funds of the gouty Earl who points out his pedigr[ee] and ignores the clerk who calls his attention to th[e] unpaid mortgage.

The plight of their children is reflected in th[e] chained dogs. Viscount Squanderfield gazes into [a] glass while his prospective wife receives the attentio[n] of Councillor Silvertongue, the lawyer in the settle[-] ment.

Besides exhibiting the Earl's poor taste, the ol[d] master copies on the walls—scenes of violence, murd[er] and martyrdom—intimate the consequences of th[e] match, while the source of his financial straits, an[d] ultimately of the marriage itself, can be seen throug[h] the open window. It is a half-finished building, [a] blundering example of the Palladian style, introduce[d] in this form by Burlington and Kent.

140 Marriage à la Mode II
Shortly after the Marriage

(Reproduced in colour on the cover)

It is early afternoon and the couple have met over th[e] Viscountess's breakfast after their respective pleasure[s] of the night. *En négligé*, she yawns enticingly; th[e] unresponsive Viscount, on the evidence of the lac[e]

cap in his pocket and his broken sword, has spent the night drinking and visiting a brothel. Their tasteless apartment is being restored to order by the neglected servants after the Viscountess's lively soirée of cards and music.

The subjects of the pictures—a Cupid among ruins, three saints and a reclining nude (if nothing more) half-covered by a curtain, display further aspects of the dissolute life, while the Steward departs with a pile of unsettled bills. His gesture is sanctimonious and the book in his pocket, 'Regeneration', shows he is a Methodist. The room is supposedly modelled on the house at 5 Arlington Street to which Walpole moved in 1742; the lavish decoration in indifferent taste may reflect the allegations of corruption. The Viscount may resemble Francis Hayman.

141 Marriage à la Mode III
The Visit to the Quack Doctor
(Reproduced in colour on p61)
A young girl, hardly more than a child, has contracted her lover's venereal disease and has been brought to the squalid appartment of a quack, furnished with a profusion of illustrative detail—a stuffed crocodile, a diseased skull, a skeleton which makes advances to an anatomical figure, and elaborate machines invented by the quack for straightening the shoulders and pulling corks. It appears that, apart from the consequences of immorality, the jocular callousness of the Viscount is the theme. Action has thus given place to expression. Traits of character seem to provide the chief subject in themselves, but some commentators have felt the need for further explanation. The quack is identified as Dr Misaubin, known as Monsieur de la Pillule, after his famous product, one of the doctors who failed to save the Harlot. The woman with the clasp knife, either his assistant or the young girl's bawd, has the initials F.C. or perhaps E.C. tattooed on her breast; she is more likely to be Betsy Careless, who was later known as a brothel keeper, than Fanny Cock, daughter of the auctioneer, but an ambiguity is not impossible.

142 Marriage à la Mode IV
The Countess's Morning Levée
(Reproduced in colour on p61)
In the absence of her husband—who has succeeded to the Earldom—the Countess has developed her intrigue with Silvertongue, who entreats her to accompany him to a masquerade, and suggests likely costumes—a monk and a nun—from the painted example on the screen behind him. The company includes an Italian castrato singer, the rage of society at the time, and a fop who, like the Countess, has his hair in curlers, a habit that was generally more acceptable than Hogarth seems to find it.

The accompanying paintings depict the various guises of Jupiter in his pursuit of love, while the negro servant points to the horns of Actaeon and the consequences of the invasion of privacy; the custom of the levée was often blamed for encouraging vice. The book on the sofa is a translation of 'Le Sopha', a licentious novel by Crebillon fils, published in England in 1742.

143 Marriage à la Mode V
The Killing of the Earl
(Reproduced in colour on p64)
The Countess has accompanied Silvertongue to the masquerade, wearing the proposed monastic costumes. They have retired to a bagnio, The Turk's Head, where they are disturbed by the Earl who has followed them. A duel results in which the Earl is wounded, and Silvertongue is seen escaping through the window while the Countess pleads forgiveness from her dying husband. The disturbance brings the master of the house, accompanied by two members of the Watch. A recording painter is at hand in the form of St Luke in the picture above the door. It becomes clear in the print that the comically crude tapestry illustrates *The Judgment of Solomon*, as if to confirm the ludicrous fact that the imminence of death is needed to expose the truer love. On top of it hangs a conventionally vacuous portrait of a silly lady equipped for riding who has made a pet of a squirrel.

144 Marriage à la Mode VI
The Suicide of the Countess
On reading in a broadsheet, now on the floor, that Silvertongue has been hanged for murder, the Countess has committed suicide by taking laudanum. It was bought by the idiot servant who is reproved by the apothecary as the doctor leaves the room, his service useless. The Countess, embraced by her already-diseased child, is dying in the house of her miserly father who prudently removes her rings, since suicides forfeit their goods. Pictures of Dutch low-life subjects completed the squalor of the scene. A contrast with the first scene is clearly intended.

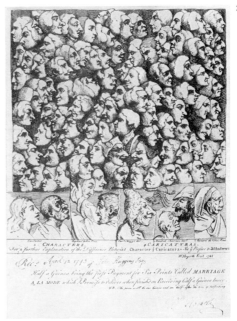

145

145 Characters and Caricaturas Published April 1743
Etching, First State, $7\frac{9}{16} \times 8\frac{1}{8}$. *Trustees of the British Museum*
Subscription ticket for the prints of 'Marriage à la Mode'. Hogarth explained that he had been 'perpetually plagued, from the mistakes made among the illiterate, by the similitude in the sounds of the words *character* and *caricatura* . . .' The purpose was to establish the difference and show that the faces in Marriage à la Mode belonged to the former category, as well as 'to prevent, if possible, personal application when the prints should come out . . .' (how is not altogether clear). 'This however did not prevent a likeness being found for each head . . .' The most important and significant part was perhaps the line which directed the seeker for further explanation to the preface to *Joseph Andrews*.

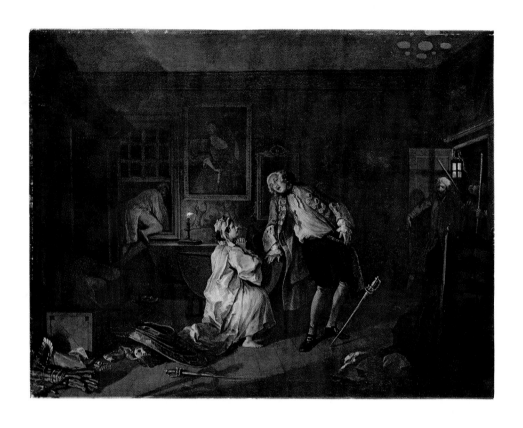

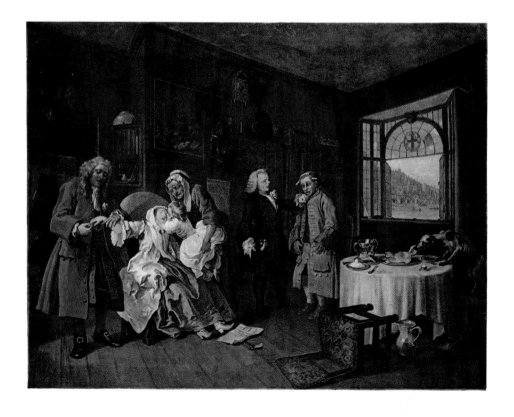

Marriage à la Mode V: The Killing of the Earl
circa 1743 (143)

Marriage à la Mode VI: The Suicide of the Countess
circa 1743 (144)

46 The Happy Marriage II *circa* 1745
The Marriage Procession (fragment)
Oil on canvas, $6\frac{1}{4} \times 7\frac{3}{4}$. *The Marquess of Exeter*

47 The Happy Marriage III *circa* 1745
The Wedding Banquet
Oil on canvas, 28×36. *Royal Institute of Cornwall, County Museum, Truro*

48 The Happy Marriage VI *circa* 1745
The Dance
Oil on canvas, $27 \times 35\frac{1}{2}$. *London Borough of Southwark, South London Art Gallery*
(Reproduced in colour on p74)

This series seems to have been conceived as a contrast to 'Marriage à la Mode'. It was probably intended as a Country Marriage, as opposed to the City Marriage of the earlier series, on the lines of Abraham Bosse's two series of engravings with these titles. Scenes i, iv and v are known only by etchings in the *Graphic Illustrations*. Scene ii was cut up before 1833. The present condition of Scene iii is an unreliable guide to the original style. The fragment of Scene ii and Scene vi show a significant attempt to bring Hogarth's sketch style to a legible finish. The general arrangement of Scene vi resembles one of Coypel's illustrations to *Don Quixote*, which may have been its source. The subject was developed into the central subject of Plate 2 to *The Analysis of Beauty*. An example of Hogarth's mnemonic notation for 'the sketch of a country-dance' is given in figure 71 at the top left-hand corner of the same plate, ' . . . in the manner I began to set out the design; in order to shew how few lines are necessary to express the first thoughts as to different attitudes . . . which describe in some measure the several figures and actions, mostly of the ridiculous kind . . .'

49 The March to Finchley 1746
(The March of the Guards towards Scotland in the year 1745)
Oil on canvas, $40 \times 52\frac{1}{2}$. Dated. *Thomas Coram Foundation for Children*

At Tottenham Court Turnpike, English guards, recalled from the Low Countries, begin their move to Finchley to protect the approach to London against Jacobite attack. A variety of incidents illustrate the dissolute behaviour of the soldiery in the foreground; behind under rigid discipline the troops march away. Rouquet's description, dictated by Hogarth, has an ironic apology for the excessive brilliance of the picture's 'undignified freshness, which is found in nature but never seen in well-regarded art collections'—anticipating Constable's sardonic observations on the same point. George II is supposed to have refused the dedication of the print (which was inscribed to the King of Prussia) with a famous remark: 'I hate bainting and boetry too! Neither the one nor the other ever did any good. Does the fellow mean to laugh at my guards?'

50 The Stage Coach Published June 1747
(The Country Inn Yard)
Etching and engraving, Fourth State, $8\frac{1}{8} \times 11\frac{7}{8}$. *London Borough of Hounslow, Hogarth's House*

A sketch of the departure of a coach was hurriedly adapted for an engraving to cover the General Election of 1747. Hogarth was reminded of an incident in a disputed election 13 years earlier and inserted it in the background. John Child, whom he had painted as a youth in 'The Assembly at Wanstead', standing as a

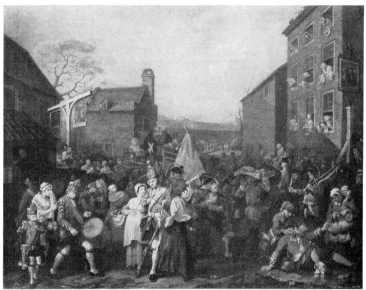

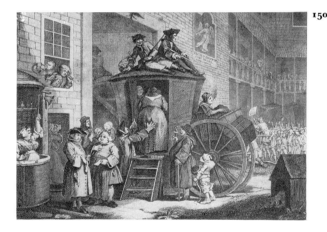

candidate in the county of Essex, was found to be aged 20. His opponents campaigned with the cry 'No Old Baby' and the pantomime which is illustrated. The family shortly had its name changed to Tylney by act of parliament. The memorable image of the old baby echoed in Hogarth's imagination; he had seen something like it at St Bartholomew's fair. It took on overtones of degenerate infantilism and was shown in the sketchbook of comic incongruities in the corner of Plate 1 of *The Analysis of Beauty*. Its possibilities were realised when the old English election joke reappeared, no doubt under Hogarth's influence, as Plate 4 in Goyas's 'Caprichos'.

154, 156

158, 160

161, 162

163, 164

167, 169

170

151 **Industry and Idleness** Published October 174⁊
Plate Eleven 'The Idle 'Prentice Executed a
Tyburn'
Etching with some engraving, Second State,
10 × 15¾. *Trustees of the British Museum*

152 **Industry and Idleness** Published October 174⁊
Plate Twelve 'The Industrious 'Prentice
Lord Mayor of London'
Etching with some engraving, Second State,
10 5/16 × 15¾. *Trustees of the British Museum*

Industry and Idleness—Drawings *circa* 1747
Trustees of the British Museum

153 1 **The Fellow 'Prentices at their Looms**
Pen, brown ink, grey washes over pencil,
10⅜ × 13. Sketch for Plate One

154 2 **The Same**
Pen and grey wash over pencil. Incised, 10⅞ × 14
Finished drawing for Plate One

155 3 **The Industrious 'Prentice Performing the**
Duty of a Christian
Pen, brown ink, grey wash over pencil, 8⅜ × 12⅝.
Sketch for Plate Two

156 4 **The Same**
Pencil, pen and grey wash. Incised in places,
10¾ × 13¾. Finished drawing for Plate Two

157 5 **The Idle 'Prentice at Play in the Church**
Yard during Divine Service
Pen, brown ink and grey wash over pencil.
Additions and correctives in black ink, 8½ × 11⅝.
Sketch for Plate Three

158 6 **The Same**
Pen and grey wash over pencil. Closely incised,
10¾ × 13⅞. Finished drawing for Plate Three

159 7 **The Industrious 'Prentice a Favourite and**
Entrusted by His Master
Pencil, pen, brown ink and grey wash, 8½ × 11½.
Sketch for Plate Four

160 8 **The Same**
Pencil, pen and grey wash. Incised, 8½ × 11½.
Possibly the final drawing for Plate Four

161 9 **The Idle 'Prentice Turned away and sent**
to Sea
Grey wash, a little pen, over rough pencil.
Incised, 8½ × 11½. Sketch and possibly final
drawing for Plate Five

162 10 **The Industrious 'Prentice out of his Tim**
and Married to his Master's Daughter
Pen, brown and grey washes over pencil.
Incised in part, 8½ × 11½. Elaborated sketch for
Plate Six

163 11 **The Idle 'Prentice Returned from Sea**
and in a Garret with a Common Prostitute
Pen, brown and grey washes over pencil. Incised
with the stylus. 8⅜ × 11⅝. An advanced drawing
for Plate Seven

66

164 12 The Industrious 'Prentice Grown Rich and Sheriff of London
Pen, brown and grey washes over slight red chalk and pencil, $8\frac{1}{2} \times 11\frac{1}{2}$. Sketch for Plate Eight

165 13 The Industrious 'Prentice when a Merchant, Giving Money to his Parents
Pen with brown ink and grey wash over pencil, $8\frac{1}{2} \times 11\frac{1}{2}$. Subject not engraved

166 14 The Idle 'Prentice Stealing from his Mother
Pen with brown ink and grey wash over pencil, $8\frac{3}{8} \times 11\frac{5}{8}$. Subject not engraved

167 15 The Idle 'Prentice Betrayed by his Whore and Taken in a Night Cellar with his Accomplice
Pen with brown ink and grey wash over pencil, $10\frac{3}{8} \times 12\frac{3}{4}$. Sketch for Plate Nine

168 16 The Industrious 'Prentice Alderman of London, The Idle One Brought Before Him and Impeached by His Accomplice
Pen with brown ink and grey wash over pencil, $8\frac{1}{2} \times 11\frac{1}{2}$. Sketch for Plate Ten

169 17 The Same
Pen with brown ink and brown and grey washes. Carefully incised, $8\frac{1}{2} \times 11\frac{1}{2}$. Finished drawing for Plate Ten

170 18 The Idle 'Prentice Executed at Tyburn
Pen and grey wash, emphasised in parts in black ink. Incised with the stylus, $9\frac{1}{8} \times 15\frac{3}{8}$. Finished drawing for Plate Eleven

After 'Marriage à la Mode' Hogarth's intention changed radically. Instead of being delicately painted for fine engraving by other hands, the series that followed were not painted at all but drawn expressly for engraving with the simple directness which suited Hogarth's own graphic ability as well as his mood. 'The Effects of Industry & Idleness', he wrote, 'Exemplified in the Conduct of two fellow prentices in twelve points were calculated for the use & Instruction of youth, wherein everything necessary to be known was to be made intelligible as possible, and as fine engraving was not necessary to the main design, provided that which is infinitely more material viz the characters and Expressions were well preserved, the purchase of them became within the reach of those for whom they were chiefly intended'. The trait that had 'prevented his attaining that beautiful stroke on copper which is acquired by early habit and great care' in fact emerged as a positive quality. Impatience with the role of artist as luxury craftsman (and failure in the luxury painting trade) left him the artist's role as common man. In reverting deliberately to popular tradition and seeking the widest sale, he made a choice that was both humanitarian and aesthetic. Yet nothing for the mass market had since the seventeenth century been drawn with such educated seriousness or engraved with such magnificent conviction. It is not only the subject that gives the fifth plate a quality which anticipates the modern-dress history-painting of 30 years later. Plates like 6 and 11 have an originality of another kind; their wide, parabolic designs point the way to the culmination of the Rococo style in Hogarth's own work.

The autobiographical notes reveal Hogarth as habitually ironical about industry and idleness. He was himself by way of being an industrious apprentice who married (though without permission) a master's daughter, but he drew Tom Idle rather like himself. What he sardonically described as his 'idle way of proceeding' had been the very foundation of his art. His irony on the subject concerned the servile connotations of conventional industry in art and the prints do not suggest that the conventions of society at large are differently regarded. They show little reason for respecting the behaviour that is conventionally respectable; they simply trace the processes of social causality. Success in its greedy way is as degrading as failure and the processional climaxes of the two stories are strangely alike, except that the popular festival of an execution engages the sympathy of the artist.

171 An Operation Scene *circa* 1745
Pencil, grey wash over red chalk indications, $8\frac{5}{8} \times 11\frac{3}{4}$.
Pierpont Morgan Library, New York
Similar in subject and arrangement to the early picture in the Tate Gallery. The design here is evidently intended for reversal in an engraving. The incident of setting fire to a doctor's wig is supposed to have occurred at Queen Caroline's deathbed. Hogarth's drawing seems to be earlier in date than *Tristram Shandy* (1760–1) in which the incident also appears.

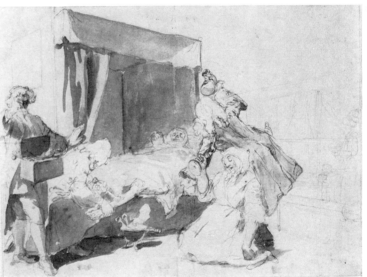

171

172 Headpiece to the 'Jacobite's Journal' 1747
Red chalk. Drawing for woodcut, $8\frac{1}{4} \times 6\frac{3}{4}$.
Her Majesty The Queen, Royal Library, Windsor
Sketch for the woodcut at the head of Fielding's weekly newspaper. The first number appeared on 5 December 1747. The sophisticated and brilliant notation of movement suggests that the primitive popular style of the finished woodcut was to some extent deliberately affected.

173a, 173b, 174

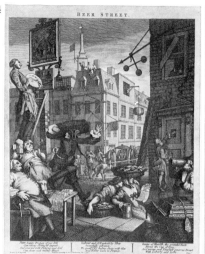 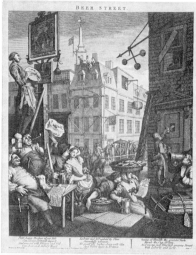 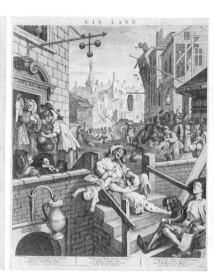

176, 178

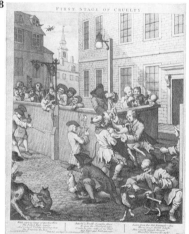 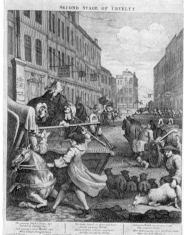

181, 185

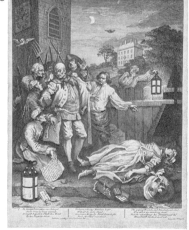 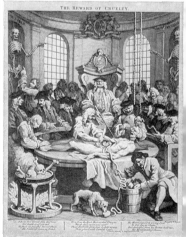

173 **Beer Street** Published February 1750/1
(a) Second State
(b) Third State
Etching and engraving, $14\frac{1}{8} \times 11\frac{15}{16}$. *Trustees of the British Museum*

174 **Gin Lane** Published February 1750/1
Etching and engraving, Second State, $14\frac{3}{16} \times 12$.
Trustees of the British Museum

The vertical designs have a dynamism that was new in Hogarth's work. A drawing for 'Gin Lane', shaded in still broader hatching, suggests that the kinship to popular woodcut style was deliberate. The breadth of the observation of normal life in 'Beer Street' (as well as the interest in the painting of a signboard) recalls the attitude characteristic of Hogarth in his 20s. The straightforward opposition of themes in companion prints belonged to a much older tradition than the complex narrative cycles of Hogarth's maturity. The social problem was attracting enlightened attention, but the sweeping simplicity of Hogarth's diagnosis was archaistic in the context of John Fielding's *Enquiry into the Causes of the late Increase of Robberies* published the month before. The social reference of the prints of this time was undoubtedly deeply felt, but it appears that the character of communication and the fact of pictorial legibility in itself were of equal significance to the artist.

The Four Stages of Cruelty Published
1 February 1750/1

175 **The First Stage of Cruelty**
Red chalk drawing, $14 \times 11\frac{7}{8}$. *Pierpont Morgan Library, New York*

176 **The First Stage of Cruelty**
Etching with some engraving, First State,
$14 \times 11\frac{1}{16}$. *Trustees of the British Museum*

177 **The Second Stage of Cruelty**
Red chalk drawing, $14 \times 11\frac{7}{8}$. *Pierpont Morgan Library, New York*

178 **The Second Stage of Cruelty**
Etching and engraving, First State, $13\frac{7}{8} \times 11\frac{15}{16}$.
Trustees of the British Museum

179 **Cruelty in Perfection**
Red chalk drawing, $11\frac{7}{8} \times 11\frac{7}{8}$. *Pierpont Morgan Library, New York*

180 **Cruelty in Perfection** Published 1 January
1750/1
Woodcut by John Bell, $17\frac{5}{8} \times 14\frac{7}{8}$. *Trustees of the British Museum*

181 **Cruelty in Perfection**
Etching and engraving, $14 \times 11\frac{3}{4}$. *Trustees of the British Museum*

182 **The Reward of Cruelty**
Drawing. Upper area in pen with brown ink and grey wash. Lower part in brush with grey, $18\frac{1}{8} \times 15\frac{1}{8}$. *Her Majesty The Queen, Royal Library, Windsor*

183 **The Reward of Cruelty**
Red chalk drawing, $14 \times 11\frac{7}{8}$. *Pierpont Morgan Library, New York*

184 **The Reward of Cruelty** Published 1 January
1750/1
Woodcut by John Bell, $17\frac{7}{8} \times 15$. *Trustees of the British Museum*

185 **The Reward of Cruelty**
Etching and engraving, Third State, $14 \times 11\frac{3}{4}$.
Trustees of the British Museum

Hogarth described the purpose and method: 'The four stages of cruelty were done in hopes of preventing in some degree that cruel treatment of poor Animals which makes the streets of London more disagreeable to the human mind than anything whatever, the very describing of which gives pain. But it could not be done in too strong a manner as the most strong hearts were meant to be affected . . . The circumstances of this set, as the two former, were made so obvious for the reason before mentioned that any further explanation would be needless. We may only say . . . that neither great correctness of drawing or fine Engraving were at all necessary . . . However, what was more material—and indeed what is most material even in the very best prints, viz the Characters and Expressions—are in these prints taken the utmost care of and I will venture to say further that . . . precious strokes can only be done with a quick Touch and would be languid or lost if smoothed out into soft engraving.' In other words, the popular style is preferable for any purpose worth the name. Impatience is in every respect better than 'a quiet turn of mind'. The tygers of wrath are wiser than the horses of instruction.

Seeking the widest market and the most popular style, Hogarth intended to have the series cut on wood. The third and fourth scenes were cut by John Bell under Hogarth's direct supervision, but woodcutting turned out to be too expensive. The traditionally cheap, vernacular medium had, in fact, been replaced by engraving, and the attempt artificially to revive it for altruistic and stylistic reasons was abandoned. Hogarth finally engraved the series on copper as usual, but the magnificent woodcuts remain, a monument to what is possibly the first sign of an uneconomic nostalgia for cheapness, if by no means the earliest of a sophisticated admiration for the popular vernacular of art.

Told that the prints were greatly admired, he answered ' . . . It gratifies me highly, and there is no part of my works of which I am so proud, and in which I feel so happy as in the series of the Four Stages of Cruelty because I believe the publication of them has checked the diabolical spirit of barbarity, which, I am sorry to say was once so prevalent in this country'. Another expression of his pride is revealing in a different way. In his *Apology for Painters* he wrote that 'I had rather, if cruelty has been prevented by the four prints, be maker of them than of the [Raphael] cartoons, unless I lived in a Roman Catholic country'. Hogarth knew (and said) that there was as much cruelty in a Roman Catholic country as anywhere. He may have intended only a mock confession that the rewards of being Raphael would have corrupted even him. If he meant anything else, it was an apparent admission that his humanitarian faith was strictly relative to the purpose of establishing something analogous to history-painting in England. In another country would another faith have served the same artistic function? If we know Hogarth at all, it must seem doubtful. Very likely his statement should be interpreted in the light of his habitual and bottomless irony about himself.

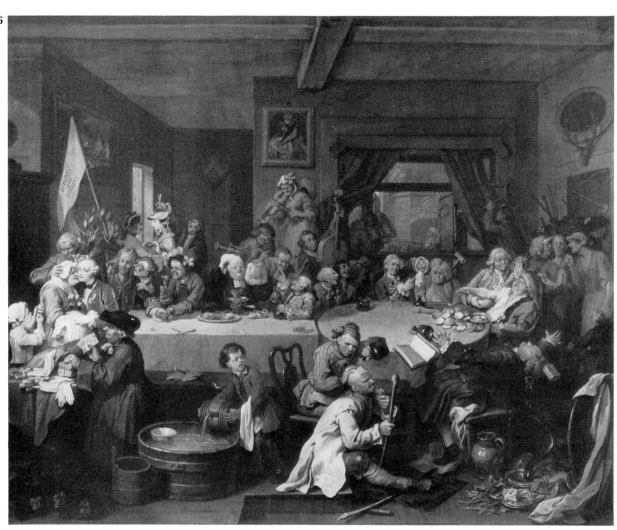

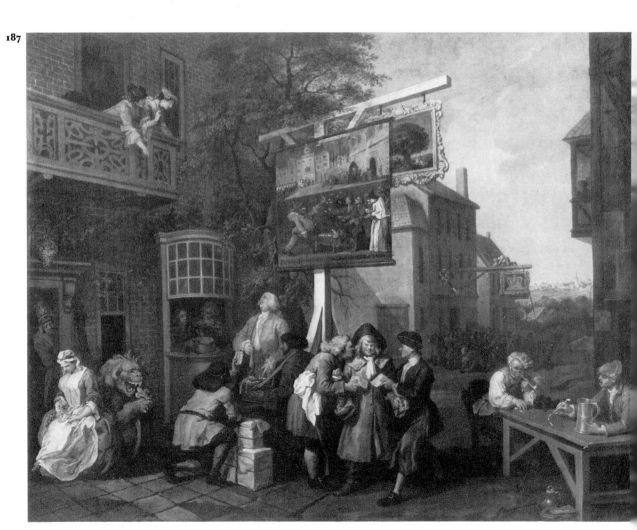

An Election *circa* 1754
Oil on canvas, 40 × 50 each. *Trustees of Sir John Soane's Museum, London*

186 **An Election Entertainment**

187 **Canvassing for Votes**

188 **The Polling**
(Reproduced in colour on p83)

189 **Chairing the Member**
(Detail reproduced in colour on p2)

Based on the Oxfordshire contest in the General Election of 1754. The milestone, however, shows the town represented to be 19 miles from London. The treat in the first scene is given by the Whigs. The two candidates are among their supporters at the table on the right. The group may be a paraphrase or a parody of a Last Supper, with its motif of betrayal. In the second scene a Tory inn with anti-government slogans is the setting for competing attempts at bribery. Behind, a Tory mob besieges a Whig tavern, infuriated by taxation, and there are symbolic references to the decline of British fortunes, especially at sea, as a result of such activities. The third shows the polling booth; voters include an imbecile and a dying man. Britannia in her coach is about to be allegorically overturned by neglect of the national interest. In the final scene the successful candidate (modelled on a wealthy grandee and turncoat who, in fact, lost for the Whigs at Bridgewater) is borne unsteadily through the town to the tune of a syphilitic fiddler.

The complex and splendid design which seems both to elevate and topple the new member is typical of the series. There is no evident *parti pris*; the satirical bite in the observation enforces no point but the general one that vitality tends to be vicious and decrepitude ludicrous. Nevertheless, the splendid vigour of the visual realisation gives an irresistible sense of unity and energy to each scene. Hogarth may have thought of parties and factions, indeed the whole community as irredeemably corrupt. But the consummate beauty of the realisation is read as an expression, not of corruption, so much as of something that underlies it, a pulse of life. Not of political life; in Scene 3 it appears that division of opinion and voting in itself are sources of national weakness and Hogarth had evidently no sense that it was a mark of progress that the Oxfordshire seats were contested at all. (This was the first election to be fought there since 1710; in the counties a carve-up was convenient for the local tycoons. The Tory success at Oxfordshire was, in fact, reversed on a petition by the Whig majority on grounds of corruption.) Humanity, in the view to be gathered from these pictures, is surely rotten, but its wriggling pullulation in the brief space before death is the single basis, not for hope of course, but for curiosity, laughter and sardonic delight. Hogarth's interest in popular clarity and perhaps particularly in signs like the board in Scene 2 had miraculously purified his palette. 'Chairing the Member' is a triumph which spans the two major European traditions, echoing both Rubens and Le Brun. Goya in his turn may have had the print in mind when he painted 'The Fight with Clubs' for the Quinta del Sordo.

189

190 **Frank Matthew Schutz Being Sick**
circa 1755–60
Oil on canvas, $25\frac{1}{4} \times 30$. *John Todhunter, Esq*
Frank Matthew Schutz married in 1755. An inscription on the back of the canvas records that the new Mrs Schutz commissioned this painting by way of reproving his drunkenness; it does not say if she chose the inscriptions from Horace. The words on the wall read, in translation: 'Not long ago I kept in shape for the girls.' Bowdlerised on the instructions of a later member of the family to make it appear that Mr Schutz's indiscretions amounted only to reading in bed.

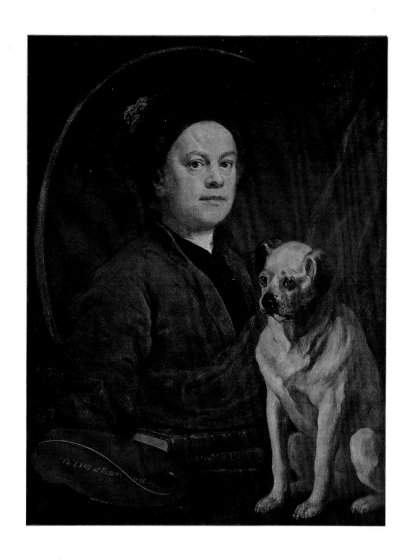

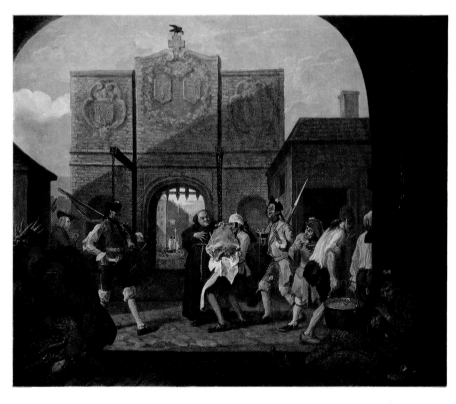

Portrait of the Painter and his Pug
1745 (135)

The Roast Beef of Old England, &c
1748 (136)

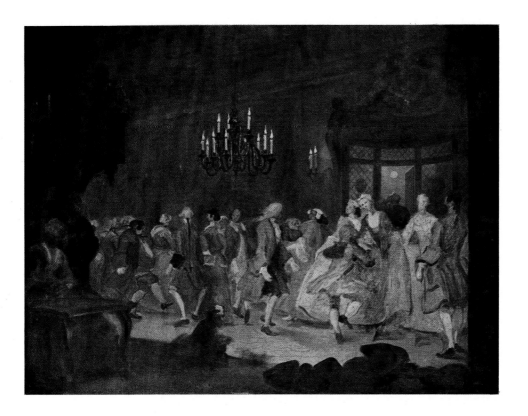

The Analysis of Beauty

Faced with seeming rebuffs, Hogarth's recourse in the later 1740s was to isolate in his objective two opposite and complementary aspects and then to pursue them severally with astonishing resource. The character of imagery as a communication he explored in the independent popular prints. The other aspect, without which his aim was only half fulfilled, the intrinsic quality of painting in itself, the 'beauty' (although, except in his title, he was chary of the word) he analysed quite separately in a book. Readers of *The Analysis of Beauty* find a richer and subtler book than current ideas of it lead one to expect. The famous line with which Hogarth had baited the palette in his self-portrait is hardly more than incidental to a wide-ranging survey of the visual resources of art and their roots in nature. This in itself was original. Hogarth's disinterest in the hierarchies of subject matter and style, which had formed the staple theme of such books before, was as defiantly unacademic as his popular prints. The Line of Grace itself, a three-dimensional serpentine rhythm, is considered in the light of a psychology of the perception of form which remains perfectly credible, and indeed so relevant to the psychological aesthetics of modern art as to suggest that in Germany, where the *Analysis* was translated within a month, it contributed something to the mainstream of aesthetic philosophy that it never had in Britain. It is true that 'the *Analysis* is the first work . . . to make formal values both the starting point and basis of a whole aesthetic theory'. Yet even this commendation places a limit on understanding the book. The respect in which Hogarth's aesthetic is both traditional and perennially new is precisely the respect in which his analysis, so far from being formalist, regards beauty not merely as a line or form but as a function of figurative effort. This is how he identifies a single principle of intricate beauty in both imagery and nature: 'The active mind is ever bent to be employ'd. Pursuing is the business of our lives; and even abstracted from any other view, gives pleasure. Every arising difficulty, that for a while attends and interrupts the pursuit, gives a sort of spring to the mind, enhances the pleasure, and makes what would else be toil and labour, become sport and recreation . . . Intricacy in form, therefore, I shall define to be that peculiarity in the lines, which comprise it, that *leads the eye a wanton kind of chase*, and from the pleasure that it gives the mind, entitles it to the name of beautiful . . .'

191 **The Analysis of Beauty, Plate One** Published
5 March 1753
Engraving, Third State, $14\frac{5}{8} \times 19\frac{5}{16}$. *Trustees of the British Museum*

The scene in the centre is set in the statuary yard of Hogarth's friend, the sculptor Henry Cheere, at Hyde Park Corner, recalling Clito's yard which was the setting of Socrates' discussion of beauty in Xenophon's *Memorabilia*. The sculptures demonstrate points in the argument and the comedy of their incongruous juxtaposition supports Hogarth's case against the Ideal. In the top centre Fig. 26 shows the serpentine line twisted round a cone. Figs. 49 and 50 demonstrate degrees of curvature in the Line of Beauty and the Line of Grace between the 'mean and poor' and the 'gross and clumsy'. Fig. 53 at the bottom shows the same gradations in the lines of a stay. The sketchbook in the right-hand corner and the statue beyond (Figs. 18–20) illustrate Hogarth's pioneer theory, introduced under the heading of Quantity, of incongruity as the foundation of humour, 'when improper or incompatible excesses meet . . .' The passage gives a sense that this subtle order of Quantity is the most congenial of all to Hogarth. Elegance is found to militate against it; one purpose of the book was to excuse Hogarth from offering in his painting what would conventionally be considered beautiful. His sly and paradoxical praise of cherubs (Fig. 22) suggests that even the Grand Style cannot dispense with the ludicrous.

192 **The Analysis of Beauty, Plate Two** Published
5 March 1753
Engraving, First State, $14\frac{9}{16} \times 19\frac{5}{8}$. *Trustees of the British Museum*

In the centre, the subject is a country dance derived from the ball in 'The Happy Marriage'. The couple on the left are separated a little to elucidate their elegance in contrast with the more rustic figures beyond; on the third state the man was converted into a portrait of the future George III, apparently as a compliment to the Prince from whose patronage much was expected. At the end of the *Analysis* under the heading of Action, Hogarth dealt at length with dancing, including both the minuet and country-dancing, and stage action, in particular the 'distinctly marked characters' of the Italian Comedy, as examples of the linear expressiveness of movement. The passage is the real climax of the book. Hogarth meditates on the physical basis of pictorial meaning and identifies the same meaning in the performing arts. At the top, the extraordinary abstracted landscape (Fig. 89) and its impressionistic pendant (Fig. 91) are intended to illustrate the true gradations of aerial perspective and the disagreeable neglect of it.

193 **The Analysis of Beauty: An Old Man's Head by Fiammingo** 1753

Pencil, numbered in pen '86'; slight heads of women numbered '3' to '7' below, $7\frac{7}{8} \times 6\frac{1}{4}$.
Trustees of the British Museum

Study for Fig. 98 in Plate I. Drawn from a cast of the head of the statue of St Andrew in St Peter's by François Duquesnoy or a work deriving from it. The example was a starting point for Hogarth's discussion of the Face. He wrote: ' . . . the old man's head was model'd in clay, by Fiammingo (and not inferior in its taste of lines, to the best antique) for the use of Andrea Sacchi, after which model he painted all the heads in his famous picture of St. Romoaldo's dream: and this picture hath the reputation of being one of the best pictures in the world. These examples are here chosen to exemplify and confirm the force of serpentine lines in a face . . .' This head was compared with Hogarth's own Hudibras (Fig. 106), exemplifying 'the mean and ridiculous effect' of a head 'totally divested of all lines of elegance'.

194 **The Analysis of Beauty: A Capital of Hats and Periwigs** 1753

Pen and grey wash numbered '37' in red, $7\frac{7}{8} \times 6\frac{1}{4}$.
Trustees of the British Museum

Finished study for Fig. 48 in Plate I. The text discusses how pleasing forms are composed: 'Nature, in shells and flowers, etc. affords an infinite choice of elegant hints for this purpose; as the original of the Corinthian capital was taken from nothing more, as is said, than some dock-leaves growing up against a basket. Even a capital composed of the awkward and confin'd forms of hats and periwigs . . . in a skillful hand might be made to have some beauty.' The ostensible illustrative purpose in the plates to the *Analysis* sometimes hardly accounts for the sly delight in incongruity.

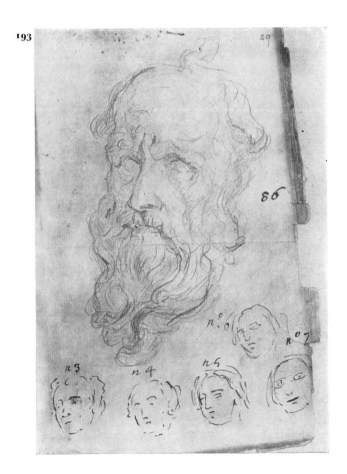

193

The Later Portraits

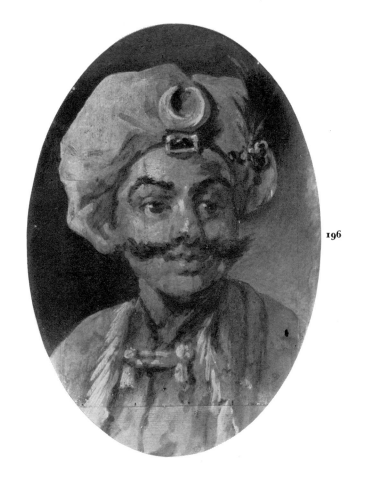

The polarisation of Hogarth's activity towards 1750 between popular communication and the aesthetics of art was evident when he returned to portraiture. To the portrayal of people he added a separate genre, the portrait of style. His image of the physical character of a sitter, when there was no other end in view, was as substantial as before but more delicately responsive. Paint was now flexible and ductile in his hands, capable of describing a head fluently and variously. But there is nothing in Hogarth's work, or anyone else's, quite like the isolated masterpiece of his servants, the only picture that was ever solely and sufficiently united by what it is that humanity has in common.

The characteristic works of this time were of the opposite kind. They were pictures of the art and artifice that have coloured the portrayal of man. Sometimes portraiture seems to be a branch of the human comedy. Hogarth's friend Pine, the engraver, had already been saddled with one objectionable image and a nickname as a result of the misadventure in Calais; it was no more than friendly to show him capable of sustaining a more dignified persona in the likeness of a Rembrandt self-portrait. Possibly none of those concerned could be sure how seriously the transpation of the Garricks into the terms of French allegorical portraiture was meant; there was naturally some trouble with the sitters. One or two of these pictures are 'fits of pleasantry' like that which produced the capriccio head of a Turk on the spur of the moment in the Beef Steak Club. Hogarth's touch in some of the portraits of the 1750s had the painterly freedom of a European artist. The sober garment of the Dutch style suits him well. But in another mood it may have seemed to him that all portraiture is a kind of masquerade.

195 **The Honourable Edward Montagu** *circa* 1749–50
Oil on canvas, 22 × 17. *Trustees of the Earl of Sandwich's 1943 Settlement*

196 **A Turk's Head** *circa* 1750–5
Distemper on panel, oval, 26⅜ × 18⅜. *Angus A Browne, Esq*

A label on the back reads: 'This sketch (in size) I saw when a boy, made by Hogarth, in a fit of pleasantry, one evening in the Painting Room at Covent Garden Theatre . . .' The writer is unknown. The painting room was the meeting place of the Beef Steak Club, founded by John Rich in 1735 with Hogarth as an original member. Hogarth's membership lapsed and he was re-elected in 1742. The rectangular box-lid on which the 'Turk's Head' was painted in the unusual medium of scene-painter's distemper measured 21 × 11⅞ inches. Later it was cut at the corners and made up at all four sides to form the present oval. The collection of W H Forman, from whom the Callaly Castle pictures descend, owned 'The Staymaker', 'The Fairies Dancing' and 'Satan, Sin and Death' as well as the 'Turk's Head'. He was evidently in sympathy with Hogarth's sketches. This panel foreshadows the capriccio Oriental heads by continental painters. A trade card of 1725 with a Turk's head attributed to Hogarth may be by him; the design has no connection with the painting. The famous Turk's Head bagnio in Covent Garden was the setting of Scene v in 'Marriage à la Mode'; various Turk's Head taverns played a part in the artistic affairs of the time, notably that in Gerrard Street where the painters who sought to set up a state academy met on 13 November 1753. Comic Turks figured in the Commedia dell'Arte; John Rich was a famous Harlequin and it may be that the subject sprang directly from a production at his theatre.

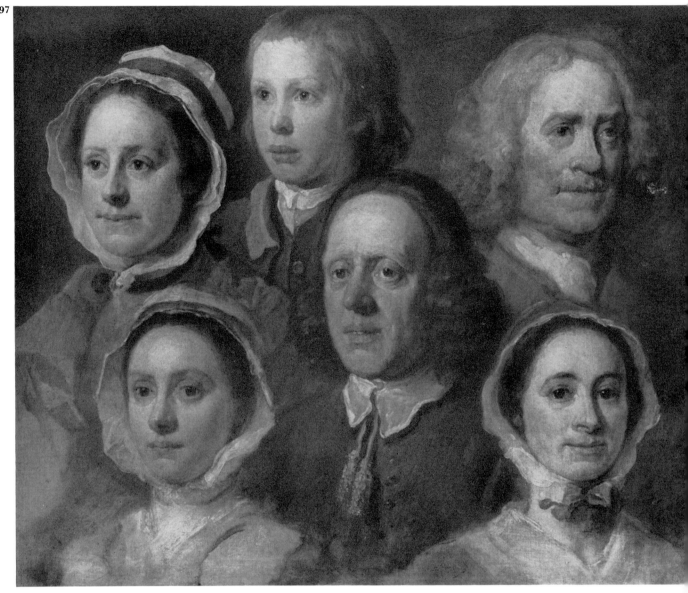

197

198

197 **Hogarth's Servants** *circa* 1750–5
Oil on canvas, 24½ × 29½. *Tate Gallery*

One of the portraits done for his own pleasure whic[h]
remained in Hogarth's collection at his death. In h[is]
old age he is recorded to have wished to keep po[r]-
traits of family and friends around him. Only the o[ld]
man, Ben Ives, is identifiable. Hogarth's acute stud[y]
of the ages of man as seen in the changing aspects [of]
the face was reflected in the *Analysis*, from the '. . . so[rt]
of settled firmness . . . aided by an air of acquire[d]
sensibility', which he noticed at thirty, to the 'furth[er]
havoc time contrives to make after the age of fifty .[. .]
leaving to the last a comely piece of ruins'. The assem[-]
blage of portraits, disdaining formal compositio[n]
developed from the additive, piled-up designs of t[he]
prints of heads made in the 1730s. The consiste[nt]
vision and sympathy give it a unity peculiar to H[o]-
garth.

198 **A Lady in Brown** *circa* 1755
Oil on canvas, 22 × 18. *Ferens Art Gallery,
Kingston upon Hull Corporation*

199 John Pine *circa* 1755

Oil on canvas, oval, 28 × 24½. *Beaverbrook Foundations, Beaverbrook Art Gallery, Fredericton, New Brunswick*

The portrait of John Pine, like that of 'A Lady in Brown' is an essay in the manner of Rembrandt. Pine, an engraver in London and personal friend of Hogarth, helped petition for the Copyright Act and was a governor of the Foundling Hospital. He accompanied Hogarth to France in 1748 and on their return was included in the picture of 'Calais Gate' as the fat friar. He was left with the nick-name 'Friar Pine', which did not amuse him.

199

200 David Garrick and his Wife 1757

Oil on canvas, 52¼ × 41. Signed. *Her Majesty The Queen*

After Hogarth's death his widow gave this portrait, unpaid for and apparently unfinished, to Mrs Garrick (Eva-Marie Veigel). Although formerly the best of friends, it is said that artist and sitters had quarrelled over the picture and that Hogarth painted out Garrick's eyes as a result.

The composition may be a parody of 'Colley Cibber and his Wife' by the artist whose success Hogarth most resented, J B Van Loo.

200

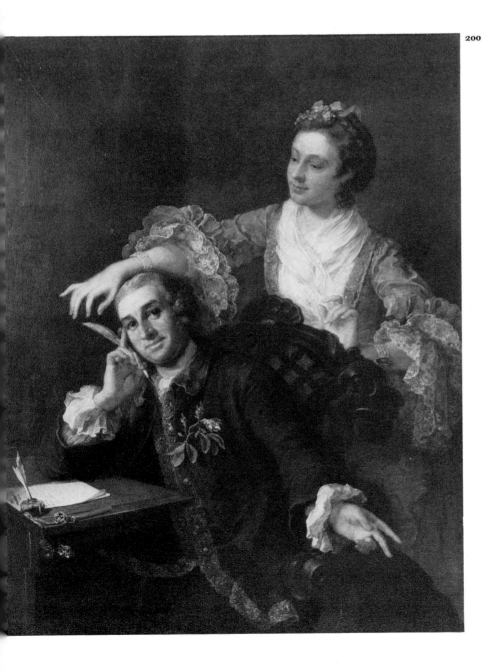

201

201 **William Huggins** 1758

Oil on canvas, oval, 18 × 15¾. *Mrs Donald F Hyde, Somerville, New Jersey.*

William Huggins, son of the Warden of the Fleet and an official at Hampton Court, was a close friend of the painter and evidently a good-natured, ineffectual man. He wrote the libretto for an oratorio, *Judith*, which was a fiasco (Hogarth's 'Chorus of Singers' is engaged in rehearsing it). His translation of Orlando was credited to another writer; his translation of Dante, the first in English, which Hogarth declined to illustrate, was never published. A bust of Ariosto and a tablet commemorate these achievements in the background of the portrait, designed as a pendant to that of his father painted in the early 1740s. William Huggins drafted the Engravers' Copyright Act and was blamed for its loopholes; he bought from Hogarth a version of 'The Committee of the House of Commons' and the Tate 'Beggar's Opera'.

202 **Mary, Queen of Scots** 1759

Oil on canvas, 23¼ × 20. Signed and dated.
From the Petworth Collection

An example of the 'fanciful' portraits of the later 1750s, where the sitters are portrayed in historic roles.

The sitter is Mary Woffington, occasionally confused with her sister Peg, of theatrical fame. She married the Hon Robert Cholmondeley in 1746

202

203 **James Caulfield, 1st Earl of Charlemont**

circa 1759

Oil on canvas, 23½ × 19½. *Smith College Museum of Art (Gift of Mr and Mrs R Keith Kane)*

One of Hogarth's last and most enthusiastic patrons, James Caulfield was of Anglo-Irish stock. He combined his duties as an MP and advocate of Irish independence with artistic patronage and a good deal of frolic in England, Ireland and during his frequent Grand Tours. It is said that he became 'physically debilitated' after taking a love potion on such an excursion, but he managed to remain a constant favourite among the ladies and society in general. He commissioned 'The Lady's Last Stake'.

204 **Henry Fox, 1st Lord Holland** *circa* 1761

Oil on canvas, 25 × 21. *D C D Ryder, Esq, Rempstone*

After gambling away a substantial inheritance, Henry Fox turned to politics, and by the time he sat to Hogarth had held several high governmental positions, besides recouping his earlier losses by securing the post of Paymaster-General during the Seven Years War. He appears in both plates of 'The Times'.

Although Hogarth claimed that the picture would rival a Rubens or Van Dyck, Holland was not pleased with his portrait, and paid only 20 guineas for it.

205 **Captain Sir Alexander Schomberg** 1763

Oil on canvas, 24 × 19. *National Maritime Museum, Greenwich*

Alexander Schomberg (1720–1804), younger brother of Hogarth's physician friend, Isaac, made an active and laudable career in the navy, eventually becoming commander of the Essex.

At the peace of 1763 he married Arabella Susanna Chalmers. The portrait may have been commissioned earlier and completed in time for the wedding.

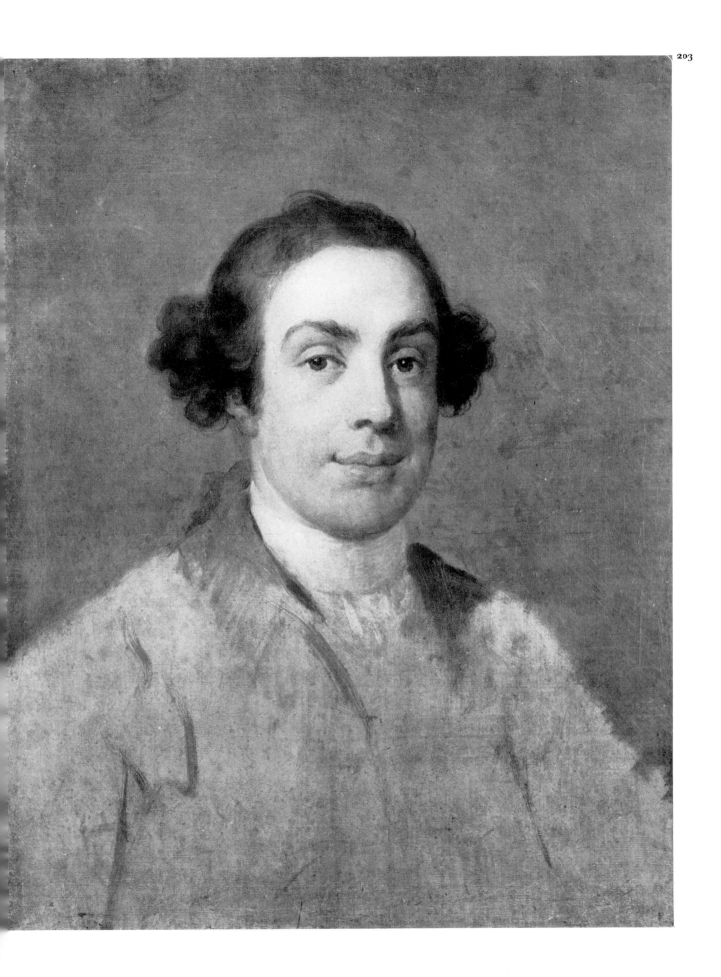

The End

In 'The Election' Hogarth had brought together the clarity of his popular manner and the rhythmical intricacy of his aesthetic ideal, combining his sense of Society with his sense of art. The outlines of his achievement were complete and his last ten years were shadowed by a deepening awareness of the forces arrayed against him. His attempt to rival the past suffered a final rebuff; a great patron refused to accept him at his own valuation as a history-painter. The experience was a crushing one because it brought, as he wrote, 'the recollection of ideas long dormant'. The obsession that it reawakened was close to paranoia.

The combat in which Hogarth was perennially locked was always as much social as artistic and in this respect also the final outcome was unhappy. His friendship with whoever was on the side of Mr Nobody and his early services to the Opposition encouraged the assumption that radicalism could count at least on his tacit support. This was mistaken; the only political element in his pugnacity was his bull-dog patriotism. Factions merely divided the nation and distracted it from greatness, patronage and art. There was a certain tragedy in the collision of the great radical critic of behaviour with the polemical radicalism of his time, if only because Hogarth was so much the more vulnerable. In his last years, in the frame of mind recorded in the autobiographical notes, he had no doubt that his antagonists were joined in a threatening conspiracy against him. The radical 'fomenters of destruction', 'the set of cheats in the traffic of old pictures', 'the great who love to be cheated', anyone who preferred art to nature, the old masters themselves, even the ludicrous figure of Time in person—all combined to persecute him.

Yet even in this extremity of his mania Hogarth's retaliation held a serious and reasoned meaning. His last prints offered a searching assessment of the real situation. He saw with a bitter clarity that cultural life required only peace and patronage, together with freedom not to be regimented or elegantly monkeyed with. The pieces for the Spring Gardens catalogue and 'The Times' developed an odd allegorical poetry in which water, sprinkled, pumped and hosed, became a symbol for the good will on which art and society depend. 'The Five Orders of Periwigs', attacking the antiquarian aesthetic of the Greek revival, pointed acutely to the fashionable emptiness of the Neo-Classical formalism that was growing out of it. In 'The Bathos' he dealt with the alternative choice for art. Time, the decrepit and malicious enemy (still with a touch of the crooked picture-dealer about him) figured in an acute critique of the masochistic 'Manner of Sinking, in Sublime Paintings', a critique in fact of all that differentiated the new Burkian Sublime from the dynamic form of 'Satan, Sin and Death'.

Below politics and patronage, underlying the dilemma of the styles, Hogarth's criticism dealt most forcefully with the moral constitution of society itself in the fearful likeness of 'The Cockpit'. English life at a crucial juncture was seen as greedy, merciless, sanctimonious, improvident and treacherous, with the privileged oligarchy presiding in its blindness, at once noble, pathetic and deeply frivolous. Hogarth's diagnosis was mad but not wrong; its rightness explains the history of the age that followed his. The gusto for graphic diagnosis was not the least of Hogarth's legacies to the age of Reynolds, but the debt to him is more profound. He posed, long before it was felt elsewhere, the aching problem of the place both of tradition and of the individual talent in a social order that does not necessarily foster either. He showed, and not to English artists only, both a new social role and a new loneliness. He provided an example for both art and anti-art. His lessons were learned in the Romantic age.

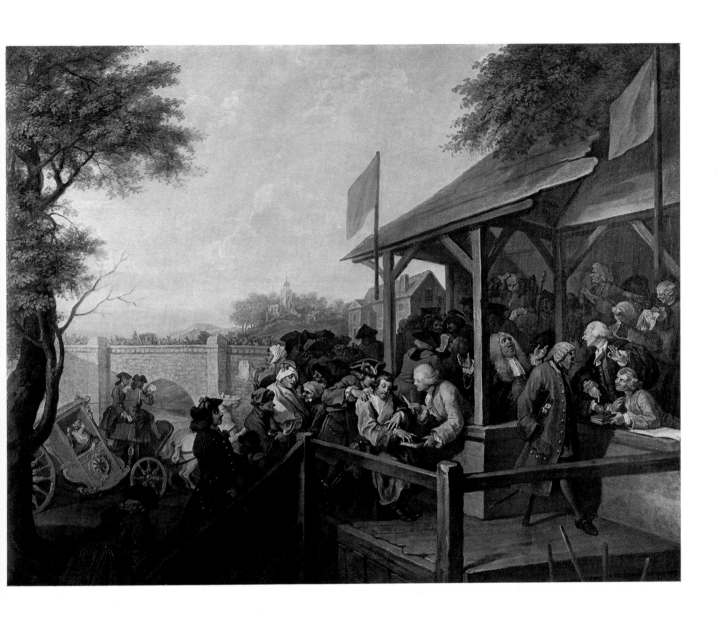

An Election: The Polling
circa 1754 (188)

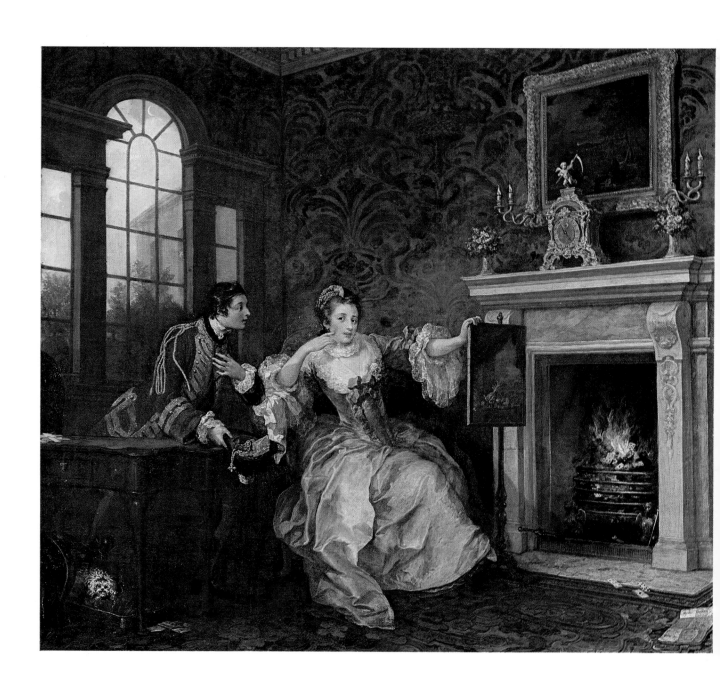

The Lady's Last Stake
1758–9 (210)

84

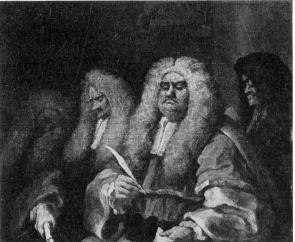

208, 209

206 The Bench *circa* 1758
Oil on canvas, $5\frac{3}{4} \times 7$. *Fitzwilliam Museum,*
Cambridge

207 The Bench published 4 September 1758.
Etching and engraving, Sixth State, $8\frac{1}{2} \times 8\frac{1}{4}$.
London Borough of Hounslow, Hogarth's House

The oil-sketch of the Court of Common Pleas assembles some of Hogarth's favourite stereotypes. In the centre, the notoriously immoral Lord Chief Justice, Sir John Willes (25 years earlier the seducer in the prints of 'Before' and 'After'), is the fat-faced image of sly lust that first appeared in 'The Christening'. The nodding judge beside him, Bathurst, had appeared on the monument in the first plate to *The Analysis of Beauty* to personify the illusion of dignified sagacity supplied by a full-bottomed wig. The design was adapted in the print to a purpose on which Hogarth brooded continually. Failure to observe the distinction between character and caricatura seemed to him gravely damaging to all that he and Fielding had stood for. A type of political caricature invented by George Townshend (an adversary both in politics and art) was sold indifferently under both labels, and the first edition was sardonically inscribed to him. The issue continued to haunt Hogarth. In the third state of the print, in a desperate attempt to avoid misunderstanding, the word 'character' was added above the design. In the fourth its place was taken by a row of heads, most of them left unfinished, which was ap-

parently to demonstrate the precise point at which the drawings of character in Raphael's 'Sacrifice at Lystra', Leonardo's 'Last Supper' and his own Bathurst would if exaggerated pass into caricature. Hogarth never abandoned the subject. The fourth state was captioned by an assistant: 'This Plate would have been better explain'd had the Author lived a Week longer'. The caption to the fifth state recorded that he had worked on the plate the day before his death.

208 Death Giving Taylor a Cross Buttock *circa* 1758.
Red chalk reinforced with black, $18\frac{7}{8} \times 15\frac{3}{4}$.
D L T Oppe, Esq

209 Taylor Triumphing over Death *circa* 1758
Red chalk reinforced with black, $19\frac{1}{2} \times 15\frac{1}{2}$.
D L T Oppe, Esq

George Taylor, a famous wrestler, was noted for his remarkable judgment of the cross buttock fall. The designs were intended for his tombstone. The final drawings are in the collection of Mr and Mrs Paul Mellon; the stone is now lost.

210 The Lady's Last Stake 1758–9
Oil on canvas, $36 \times 41\frac{1}{2}$. *Albright-Knox Art Gallery,*
Buffalo, New York (Seymour H Knox Fund)
(Reproduced in colour on p84)

In 1757, exasperated by difficulties with the engravings of 'An Election', Hogarth announced that he would thenceforward paint only portraits. Lord Charlemont, however, prevailed on him to produce one more comic history. Hogarth described the origin of 'The Lady's Last Stake' in his notes: 'Before I entirely quitted the pencil an aimiable nobleman pressed me to paint him a picture leaving the subject to me and any price I asked. The subject was a virtuous married lady that had lost all at cards to a young officer wavering at his suit whether she should part with her Honour or no to regain the loss. The payment was noble but the manner with which it was given by a note enclosed in a letter was far more pleasing to one of my turn of mind. But this elevating circumstance had its contrast which brought on the many adversities that have since happened to me'. The story is continued in connection with the next picture.

85

211

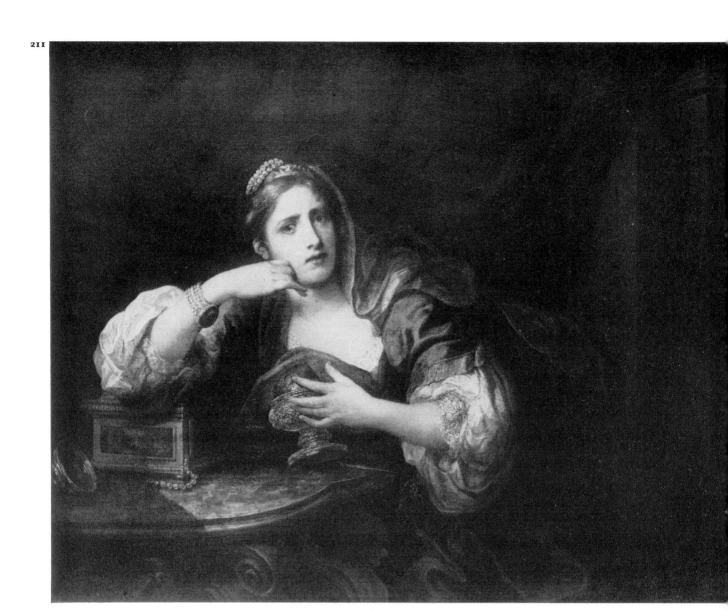

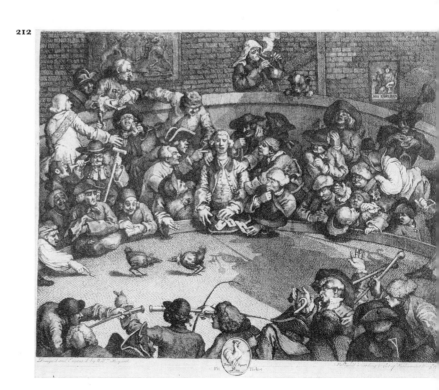

212

211 Sigismunda 1759

Oil on canvas, $39\frac{1}{2} \times 49\frac{3}{4}$. *Tate Gallery*

Hogarth's notes describe the sequel to 'The Lady's Last Stake': 'A Gentleman (now a nobleman) seeing his picture and being infinitely Rich pressed me with more vehemence to do what subject I would upon the same terms much against my inclination. I began on a subject I once wished to paint. I had ever been flattered as to expression and my whole aim was to fetch a tear from the Spectator. My figure—the actor that was to do it—was Sigismunda grieving over her lover's heart. I will aver as there are many living, ladies especially, that shed involuntary tears at it. I was convinced that peoples' hearts were as touched as I have seen them at a Tragedy—an influence that I never in my life knew before, nor knew any other painter that did. My price for it was what had been at that time bid for a picture of the Subject . . . falsely said to be by Correggio, as I had spent more time and anxiety upon it than would have got me double the money in any other way, and not half what a common face painter got in the time. I asked four hundred. See the letter! See the answer! So many falsehoods were put about. I kept my picture—he kept his money. The story was put about by the flatterers of rich men and those I am proud of ever having been at war with, the set of cheats in the traffic of pictures, with their ample earnings—a sort of beings that always have free access to the great who love to be cheated. Ill nature spread so fast—now was the time for every little dog to bark in their profession and revive the old spleen which appeared at the time my Analysis came out. The anxiety which attended this affair and the recollection of ideas long dormant, coming at a time when nature rather wants a quieter life and something to cheer it, brought on an illness which continued for a year.' The story is continued in the note on 'The Times'. The picture that excited Hogarth's wrath was in fact an example of the melancholic *fumato* of the Florentine Baroque painter Francesco Furini; it is now in the collection of the Duke of Newcastle. The pose of Hogarth's 'Sigismunda' seems to have developed out of 'The Lady's last Stake'. Recent cleaning has confirmed that the realisation of the picture was laborious but has made comprehensible Hogarth's pride in the result.

212 The Cockpit Published 5 November 1759

Etching and engraving, $11\frac{11}{16} \times 14\frac{11}{16}$. *Trustees of the British Museum*

The nobleman in the centre, recognised at the time as Lord Albermarle Bertie, is blind. Around him the gamblers argue, expostulate, strike bargains and betray him. It is clear that a parallel with Leonardo's 'Last Supper' was intended, though its expressive purport is less certain. Probably no less loaded design would have conveyed either the fury of the image or the profanity of the sport. It is nevertheless possible that the analogy had also the opposite application and that the sublimity of history painting, indeed of religion, were now seen as contaminated by the cruelty of men. The shadow over the ring is cast by a welsher, punished by being raised in a basket, who seeks to stake his watch. The symmetrical concentration of 'Cruelty in Perfection' and 'The Cockpit' is at once monumental and appalling. It left a lasting effect on the graphic tradition; this design seems to have influenced Rowlandson and, possibly through him, Daumier.

213 Frontispiece to the Catalogue of Pictures Exhibited in Spring Gardens May 1761

Etching and engraving by Charles Grignion, $6\frac{7}{8} \times 5\frac{3}{8}$. *Trustees of the British Museum*

214 Tailpiece to the Catalogue of Paintings Exhibited at Spring Gardens May 1761

Etching and Engraving by Charles Grignion, $4\frac{1}{2} \times 5\frac{1}{8}$. *Trustees of the British Museum*

215 The Five Orders of Periwigs November 1761

Etching, Second State, $10\frac{1}{2} \times 8\frac{5}{16}$. *London Borough of Hounslow, Hogarth's House*

A complex satire with a compound meaning. Satirical prints tabulating the farcical extremities of fashion were a staple popular form; they were etched, for example, by G M Mitelli (Bologna, 1634–1718) whose work was known in Hogarth's circle. Here however this convention is itself the vehicle for a secondary satire on classical antiquarianism; Stuart and Revett's *Antiquities of Athens* had lately been announced. It is implied that the study, like its subjects, will be modish, grossly dull and grotesquely elaborate. Completion of Stuart and Revett's work was more delayed even than Hogarth had foreseen. It was a foundation of Neo-Classical art and of a taste that Hogarth would surely have regarded as vain. At the left of the second row, showing the Peerian or Aldermanic order, is Hogarth's favourite personification of privilege, Bubb Dodington, the victorious candidate in 'Chairing the Member', who had become Lord Melcombe earlier in the year.

215

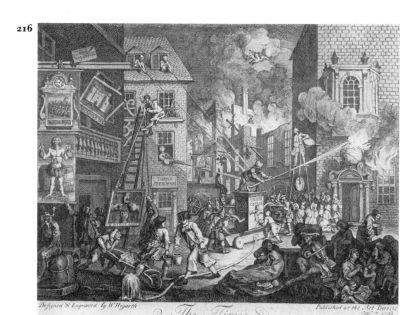

216

216 **The Times, Plate One** September 1762
 (a) Second State
 (b) Third State
 Etching and Engraving, $8\frac{9}{16} \times 11\frac{5}{8}$. *Trustees of the British Museum*

217 **The Times, Plate Two** *circa* 1762–3
 Etching and engraving, First State, $9\frac{1}{8} \times 11\frac{7}{8}$.
 Trustees of the British Museum

The only exclusively party polemic in Hogarth's work. In Plate One Bute as a fireman seeks to prevent the conflagration that is consuming Europe from taking hold on England as well. Pitt on stilts (in the earlier states disguised as Henry VIII) fans the flames, adored by those whose homes are being destroyed. In his autobiographical notes Hogarth described the origin and reception of the print. After the illness resulting from the trouble with 'Sigismunda', 'the loss of so much time and the neglect of prints occasioned by the wars abroad and contentions at home made it necessary to do some timely thing to stop a gap in my income. This produced the print called the Times, the subject of which tended to peace and unanimity and so put the opposers of this humane purpose in a light which gave offence to the Fomenters of destruction in the minds of the people, one of the most notorious of whom, till now rather my friend and flatterer, attacked me in *The North Briton* in so infamous a manner that he himself when pushed by his best friends . . . was driven to so poor an excuse as to say he was drunk when he wrote it.' This was Wilkes, who is shown with Churchill sniping at Bute with clyster pipes from attic windows. When he heard of the impending publication, Wilkes had sent a message to persuade Hogarth 'that such a proceeding would not only be unfriendly in the highest degree, but extremely injudicious; for such a pencil ought to be universal and moral, to speak to all ages, and to all nations, not to be dipt in the dirt of the faction of a day, or an insignificant part of the country, when it might command the admiration of the whole.' Hogarth was undeterred and the quarrel that ensued darkened his last years; it is described in the following note.

Plate Two is less decided. Hogarth reveals doubts about Bute's patronage and about the royal taste, caricaturing Ramsay's angular portrait of the new monarch. He is equally suspicious of the Society of Arts and of Bute-ification in general. Wilkes is in the pillory for defamation beside the Cock Lane Ghost; the parliamentary shooting party persists in firing at the dove of peace. Hogarth was probably persuaded to desist. In any event the polemic was outdated by Bute's resignation and Plate Two was never finished or published.

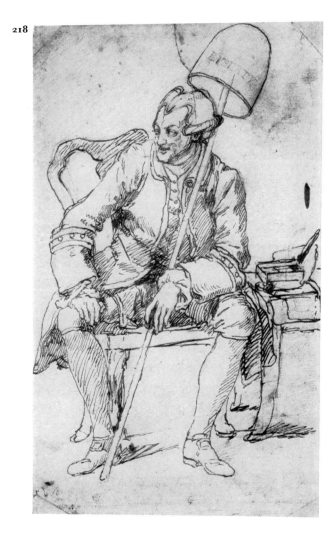

218

218 **John Wilkes** May 1763
 Pen and brown ink over pencil. Incised, $14 \times 8\frac{1}{2}$.
 Trustees of the British Museum

219 **John Wilkes** May 1763
 Etching, First State, $12\frac{1}{2} \times 8\frac{3}{4}$. *Trustees of the British Museum*

In the event Wilkes' reaction to 'The Times' was a personal and wounding attack on Hogarth himself. Hogarth described its effect: 'Being . . . at my worst in a kind of slow fever, it could not but hurt a feeling mind. My best was to return the compliment and turn it to some advantage. His portrait done as like as I could as to feature, with at the same time some indication of his mind, fully answered my purpose. The ridiculous was apparent to every eye. A Brutus, a

saviour of his country with such an aspect was so
arrant a joke that, though it set everybody else a-
laughing, it galled him and his adherents to death.
This was seen by the papers being every day stuffed
with invectives, till the town grew sick of seeing me
always (attacked) at length. . . .' The drawing was
probably begun on 6th May 1763, when Wilkes was
arraigned in Westminster Hall. The print was devised
as a pendant to 'Lord Lovat', the Jacobite traitor whose
portrait Hogarth had published seven years earlier.

220

220 The Bruiser August 1763

Etching and engraving, Second State, $13\frac{1}{2} \times 10$.
Trustees of the British Museum

When Churchill announced his intention of retaliating
for 'The Times', David Garrick wrote to him: 'I must
entreat you by the Regard you profess to Me, that
you don't tilt at my friend Hogarth before You See
Me—You cannot sure be angry at his print? There is
surely very harmless, tho very entertaining stuff in it—
He is a great and original Genius, I love him as a Man
and reverence him as an Artist . . .' Churchill's
Epistle was however published at midsummer 1763.
Hogarth described it and his own reply: '. . . Churchill,
Wilkes' toadeater, put the North Briton into verse in
an Epistle to me, but as the abuse was the same, except
for a little poetic heightening, which always goes for
nothing, it not only made no impression but in some
measure effaced the Black Stroke of the North Briton.
However, having an old plate by me with some parts
ready such as the background and a dog, I thought
how I could turn so much work laid aside to account,
so patched up a print of Mr. Churchill in the char-
acter of a Bear. The satisfaction and pecuniary ad-
vantage I received from these two prints, together with
constant Riding on horse back, restored me as much
health as can be expected at my time of life. What may
follow God knows. Finis.' This was not quite the end
of the story. Hogarth continued to work on his notes
after drafting the foreboding conclusion and his con-
cluding print 'The Bathos' was engraved in the follow-
ing year. There was nevertheless a quality akin to
self-destruction in appropriating to his purpose the
plate of his own portrait, which served as frontispiece
to his collected works. Hogarth regarded the likeness
to a bear as more insulting than it may generally
appear; for him there was an aesthetic antithesis
between the earlier and later significance of the plate.
In *The Analysis* he wrote that 'we may . . . *lineally*
account for the ugliness of the . . . bear . . . which (is)
totally devoid of this waving-line. . .'

221 The Bathos (drawing) 1764

Pen with brown ink over red chalk. Incised with
stylus, $10\frac{1}{8} \times 13$. *Her Majesty The Queen, Royal
Library, Windsor*

222 The Bathos April 1764

Etching and engraving, $10\frac{1}{4} \times 12\frac{13}{16}$. *Trustees of
the British Museum*

A mock sublime allegory, borrowing appropriately
from Salvator Rosa, of the havoc wrought by the
Sublime taste in art. The title is based on Pope's
Peri Bathous (itself a parody of Longinus's *Peri
Hypsous*), which illustrated the same situation in
poetry. The allegory has also a personal application.
Hogarth characteristically regarded the eclipse of his
artistic ideal and his own decline as the collapse of the
universe and the end of the world. Time expiring
bequeaths every atom of himself to Chaos. His testa-
ment is witnessed by the Fates.

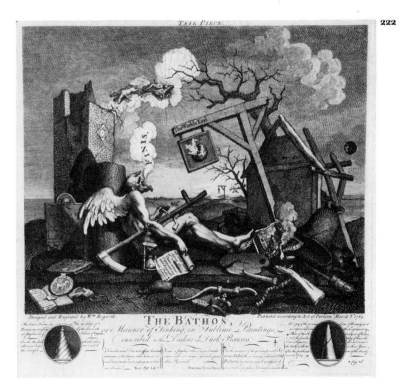

222

89

Chronology

Reference is made to a few major works not included in the exhibition

1663 or **4** 24 January: Richard Hogarth born.

1689 Richard Hogarth by this time settled in London, school teacher and author of at least one text book.

1690 4 November: Richard Hogarth marries Anne Gibbon (born 1661).

1697 10 November: William Hogarth born.
28 November: Baptized at St Bartholomew the Great.

1699 23 November: Mary Hogarth born.

1701 Move to St John's Street.
31 October: Ann Hogarth born.

1703 Move to St John's Gate where Richard Hogarth opens a Latin-speaking coffee house.

1707 or **8** Coffee house fails and Richard Hogarth is confined to the Fleet Prison for debt. By the end of 1708 the family is living within the Rules, in Black and White Court.

1712 9 September: Richard Hogarth freed from the Fleet Prison by act of amnesty. Family settles in Long Lane.

1713 2 February: William Hogarth apprenticed for seven years to the engraver Ellis Gamble of Merchant Taylors Company at Blue Cross Street, Leicester Fields.

1718 11 May: Richard Hogarth dies.

1720 23 April: William Hogarth issues shopcard, opens business as engraver at his mother's house in Long Lane.
20 October: Subscribes to Vanderbank's Academy.

1721 First dated engraving, 'The South Sea Scheme'.

1724 Joins Thornhill's free academy in Covent Garden. Living in Little Newport Street.

1725 Mary and Ann Hogarth open a milliners shop in Long Walk, near The Cloisters, St Bartholomew Hospital.
September: Hogarth engraves parody of 'Kent Altarpiece'.

1726 27 December: 'Punishment of Lemuel Gulliver', satire on Walpole, published.

1727 20 December: Commission to paint tapestry design of 'The Element of Earth' for Joshua Morris.

1728 29 January: *Beggar's Opera* opens.
28 May: Successful suit for payment against Morris.

1729 23 March: Marries Jane Thornhill (born 1708 or 9), daughter of Sir James Thornhill; they live in Little Piazza, Covent Garden.

1730 March: Sisters move their shop to Little Britain. Hogarth engraves their shopcard.

1731 Hogarths move into Thornhill's house, Great Piazza, Covent Garden.

1732 10 April: Engravings of 'A Harlot's Progress' delivered to subscribers, followed by piracies and authorised cheap set by Giles King.

1733 October: Receives permission to paint marriage of Anne, Princess Royal, but is thwarted by William Kent and Duke of Grafton. By now settled at the Golden Head, Leicester Fields.

1734 February: Offers to paint staircase of St Bartholomew Hospital.
4 May: Death of Thornhill.
25 July: Elected Governor of St Bartholomew Hospital.

1735 11 January: Founding Member of Beef Steak Club.
10 May: Death of Hogarth's mother, living with his sisters in Cranbourn Alley.
15 May: Engravers' Copyright Act receives Royal assent.
3 June: Piracy of 'Rake'.
26 June: Act goes into effect and 'Rake' engravings delivered.
October: Founds St Martin's Lane Academy.

1736 April: 'Pool of Bethesda' for St Bartholomew's Hospital finished.

1737 7–9 June: Hogarth publishes essay as 'Britophil' defending Thornhill and English art against *Daily Post* attack.
July: 'Good Samaritan' finished for St Bartholomew's.
December: J B Van Loo arrives from Paris to set up as portraitist.

1739 17 October: Founding Governor of the Foundling Hospital.

1740 May: Presents 'Captain Coram' to Foundling Hospital.
25 June: Subscribes £120 to Foundling Hospital.
November: Asked by S Richardson to illustrate *Pamela*. Nothing comes of this.

1741 25 March: Present at opening of Foundling Hospital.
20 November: Mary Hogarth dies.

1742 Paints 'Taste in High Life'.
February: *Joseph Andrews* published with Fielding's comments on Hogarth as 'comic history-painter'. Ann Hogarth moves in with Hogarths at Leicester Fields.

1743 May: Travels to Paris to hire engravers for 'Marriage à la Mode'.

1745 May: 'Marriage à la Mode' engravings delivered. Paintings subsequently exhibited by Cock but not sold.

1746 April: Rouquet's *Lettres de Monsieur*** published with commentary on the prints inspired by Hogarth.
July: Holiday with Garrick at Hoadly's at Alresford.
August: Visits St Albans to sketch Lord Lovat.
31 December: Project announced at Foundling Governors' meeting for artists to donate paintings.

1747 April: Foundling paintings finished.
15 October: 'Industry and Idleness' published.
5 November: First annual dinner of Foundling Artists.

1748 June: 'Paul before Felix' for Lincoln's Inn finished.
August: Trip to Paris and expulsion from Calais.

1749 September: Buys country house at Chiswick.

1750 30 April: Lottery for 'The March to Finchley'; won by Foundling Hospital.

1751 April: Takes part in hoax on Hudson with imitation Rembrandt etching.
7 June: Auction of 'Marriage à la Mode' paintings.

1752 26 February: Elected Governor of Bethlehem Hospital (consulted about altarpiece in February 1751).

1753 October: Attempt by artists to set up a new public academy and secede from St Martin's Lane Academy; Hogarth prepares answer.
November: *Analysis of Beauty* published.
December: German edition of *Analysis of Beauty* published.

1754 April: Society of Arts founded. Finishes paintings of *Election* and works on engravings; publication not completed till 1758.

1755 May: Commissioned to paint altarpiece for St Mary Redcliffe, Bristol.
October: Rouquet's *State of the Arts in England*, written with Hogarth's assistance, published (French edition 1754).
December: Joins Society of Arts; judge in drawing competition.

1756 By this time an inspector of the Foundling's boarded children at Chiswick.
March: 'The Invasion' (recruiting prints).
28 June: Addresses Society of Arts, recommending changes.
August: Bristol altarpiece finished.

1757 Leaves Society of Arts.
24 February: Advertisement announces that he will paint no more histories, only portraits.
June: Appointed Serjeant Painter to the King, in succession to his brother-in-law, John Thornhill.
12 November: Death of Lady Thornhill who had been living with the Hogarths.

1758 Autumn: Accepts commission from Sir Richard Grosvenor for 'Sigismunda'.

1759 Warton's *Essay on . . . Pope*, with criticism of Hogarth.
June: Grosvenor declines 'Sigismunda'
July–August: Hogarth writes poem on Grosvenor. Finishes 'Lady's Last Stake'.
September-October: Reynolds satirizes Hogarth in *Idler*, 76, 79, 82.
December: Adds inscriptions to engravings of 'Paul' and 'Moses' replying to Warton.

1760 April: Society of Artists first exhibition. Hogarth not represented. Design for *Tristram Shandy* Vol I (later in year Vol III).
April to March 1791: Illness.
July: Frontispiece for Kirby's *Brook Taylor's Perspective* finished.
25 November: Accession of George III encourages artists to agitate for an academy. Hogarth responds with *Letter to a Nobleman* which remains in manuscript.

1761 'Sigismunda' exhibited at Langfords.
5 May: Horace Walpole's interview with Hogarth. Writing *An Apology for Painters*.
9 May: Artists' exhibition opens at Spring Gardens, with seven paintings by Hogarth.
15 December: Elected to committee of Society of Artists. Italian edition of *Analysis of Beauty* published.

1762 January: Warton's second edition, with apologies to Hogarth.
March: 'Credulity, Superstition and Fanaticism' published.
20 April-17 May: Sign Painters' Exhibition initiated by Hogarth and Bonnell Thornton.
17 May: Society of Artists exhibition opens. Hogarth not represented; seems to have left Society. Raffle for 'Election' paintings prevented by Garrick's purchase. Drawings of T Morrell, Fielding and Garrick for frontispiece.
9 September: 'The Times, Plate I', followed by attacks by P Sandby, etc.
25 September: Wilkes' *North Briton* no. 17 attacking Hogarth.
October-November: Serious illness.

1763 July: Suffers a paralytic seizure. Writing notes for an autobiography and commentary on his prints.

1764 16 August: Writes will.
September: Too ill to carry on duties as Serjeant Painter. In Chiswick revising copperplates.
25 October: Returns to Leicester Fields.
25–26 October: Death.
2 November: Buried St Nicholas Churchyard, Chiswick.

Index to Lenders